Remembering
Birmingham

James L. Baggett

TURNER
PUBLISHING COMPANY

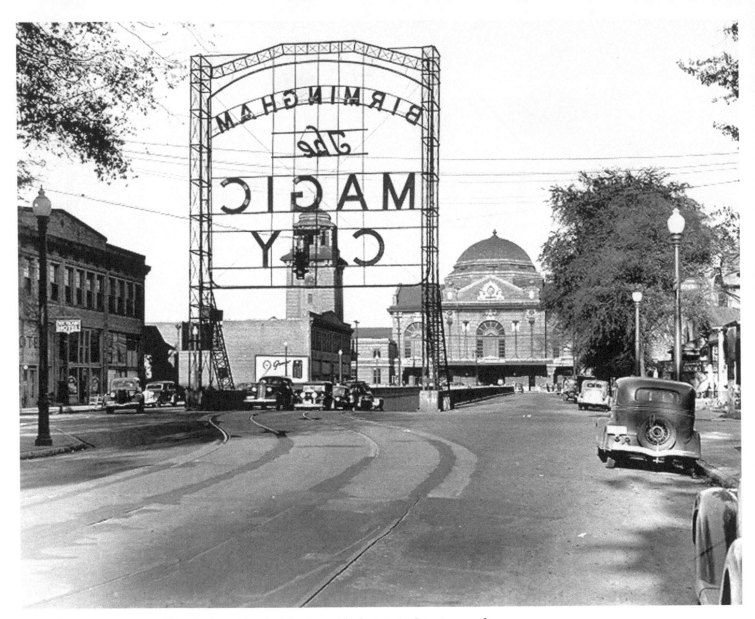

One of the iconic images of Birmingham: Terminal Station with the Magic City sign out front to greet travelers as they leave the station and head downtown.

Remembering
Birmingham

Turner Publishing Company
www.turnerpublishing.com

Remembering Birmingham

Copyright © 2010 Turner Publishing Company

Library of Congress Control Number: 2010902276

ISBN: 978-1-59652-602-0

Printed in the United States of America

ISBN: 978-1-68336-811-3 (pbk.)

CONTENTS

Workers place the first steel
column for the Tutwiler Hotel,
1913.

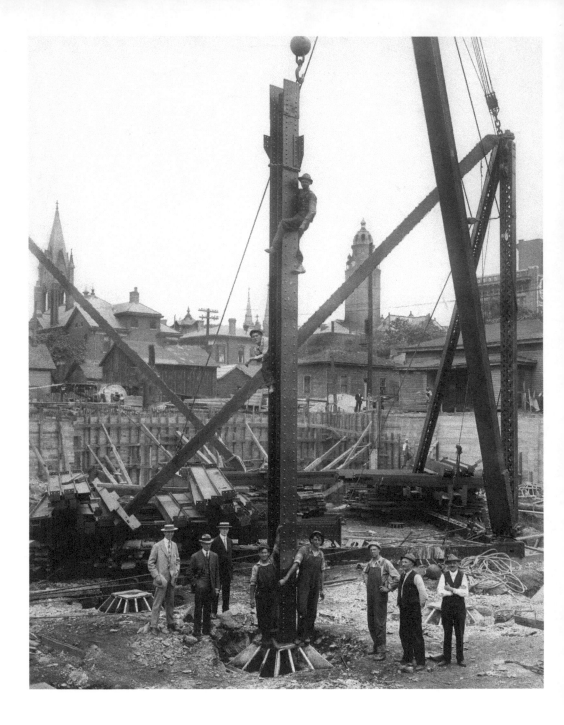

Acknowledgments

This volume, *Remembering Birmingham*, is the result of the cooperation and efforts of many individuals, organizations, and corporations. It is with great thanks that we acknowledge the valuable contribution of the following for their generous support.

Alabama Power Company
Birmingham Public Library Archives
Brice Building Company

St. Vincent's Hospital
Vulcan Materials Company
Wachovia Bank

We would also like to thank the following individuals for their valuable contributions and assistance in making this work possible:

Bill Tharpe, Alabama Power Company
Kelsey Bates, Birmingham Public Library Archives
Gigi Gowdy, Birmingham Public Library Archives
Yolanda Valentin, Birmingham Public Library Archives
Don Veasey, Birmingham Public Library Archives
Sherry Denson, Brice Building Company
John English, Vulcan Materials Company
Scott Goggins, St. Vincent's Hospital
John Lotz, Wachovia Bank
Carolyn Wallace, Wachovia Bank

PREFACE

Birmingham has thousands of historic photographs that reside in archives, both locally and nationally. This book began with the observation that, while those photographs are of great interest to many, not all are easily accessible. During a time when Birmingham is looking ahead and evaluating its future course, many people are asking, How do we treat the past? These decisions affect every aspect of the city—architecture, public spaces, commerce, tourism, recreation, and infrastructure—and these, in turn, affect the way that people live their lives. This book seeks to provide easy access to a valuable, objective look into Birmingham's history.

The power of photographs is that they are less subjective than words in their treatment of history. Although the photographer can make subjective decisions regarding subject matter and how to capture and present it, photographs seldom interpret the past to the extent textual histories can. For this reason, photography is uniquely positioned to offer an original, untainted look at the past, allowing the viewer to learn for himself what the world was like a century or more ago.

This project represents countless hours of research and review. The researchers and writer have reviewed thousands of photographs in numerous archives. We greatly appreciate the generous assistance of the archivists listed in the acknowledgments of this work, without whom this project could not have been completed.

The goal in publishing this work is to provide broader access to a set of extraordinary photographs that seek to inspire, provide perspective, and evoke insight that might assist people who are responsible for determining Birmingham's future. In addition, the book seeks to preserve the past with adequate respect and reverence.

With the exception of touching up imperfections that have accrued with the passage of time and cropping where necessary, no changes have been made. The focus and clarity of many images is limited by the technology and the ability of the photographer at the time they were taken.

The work is divided into eras. Beginning with some of the earliest known photographs of Birmingham, the first section records photographs from the 1870s through the end of the nineteenth century. The second section spans the beginning of the twentieth century to World War I. Section Three moves from World War I to World War II. And finally, section Four covers the World War II era to the 1960s.

In each of these sections we have made an effort to capture various aspects of life through our selection of photographs. People, commerce, transportation, infrastructure, religious institutions, educational institutions, and scenes of natural beauty have been included to provide a broad perspective.

It is the publisher's hope that in utilizing this work, longtime residents will learn something new and that new residents will gain a perspective on where Birmingham has been, so that each can contribute to its future.

—*Todd Bottorff, Publisher*

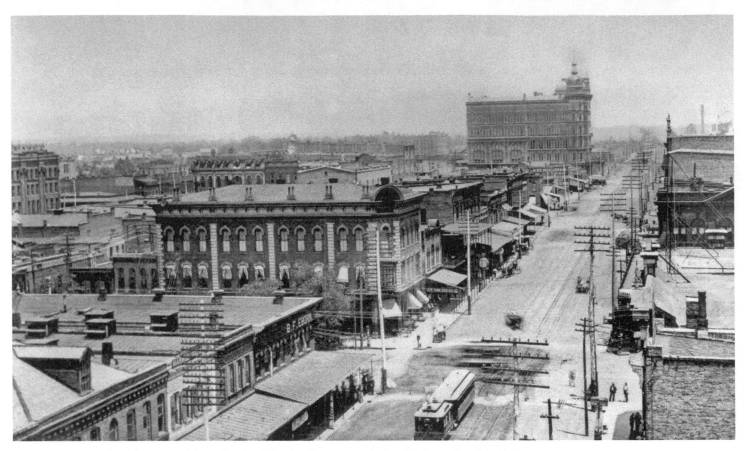

First Avenue North in the 1890s. The tallest building in the distance is the Caldwell Hotel, built in 1886. Promoted as Birmingham's first "fireproof" hotel, the Caldwell burned down in 1894.

A City of the New South

(1871–1899)

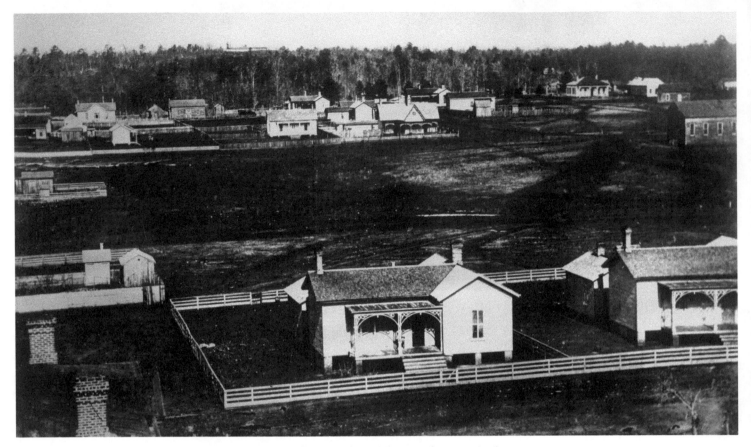

Taken in 1873, this is the earliest known photograph of Birmingham. The two chimneys in the bottom left corner are probably on the roof of the county jail. The street behind the two houses in the foreground is Fifth Avenue North, about where the Redmont Hotel now stands.

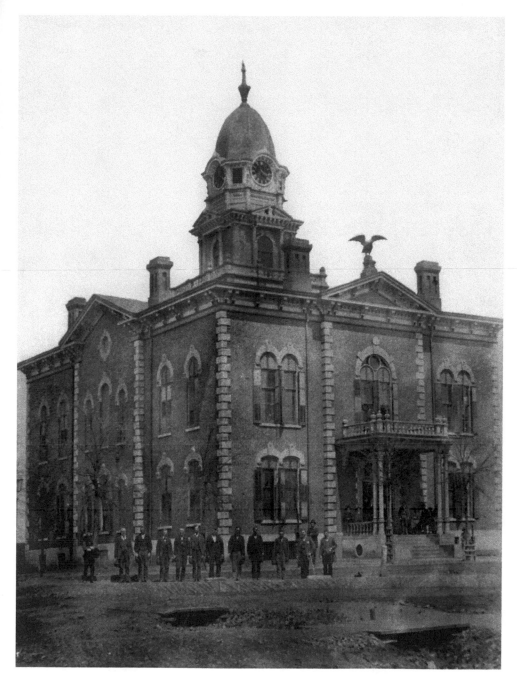

The first Jefferson County courthouse to be located in Birmingham, as it appeared in 1874. In a recent election that included many questionable campaign activities, voters had approved moving the courthouse from the nearby village of Elyton to the new city of Birmingham.

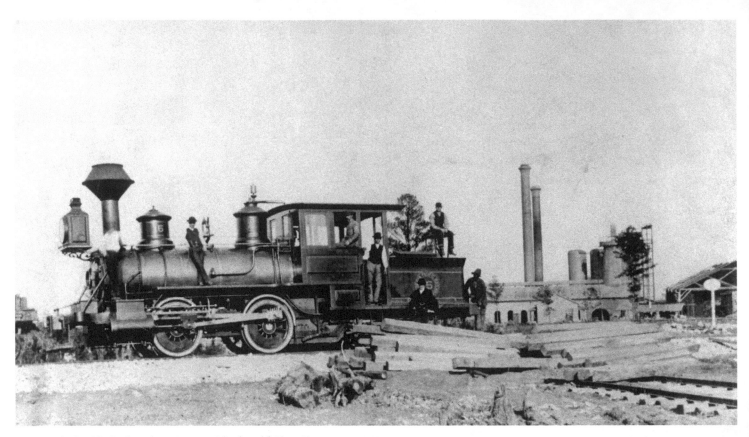

A Georgia-Pacific Railroad engine outside the old Sloss Furnaces, 1881.

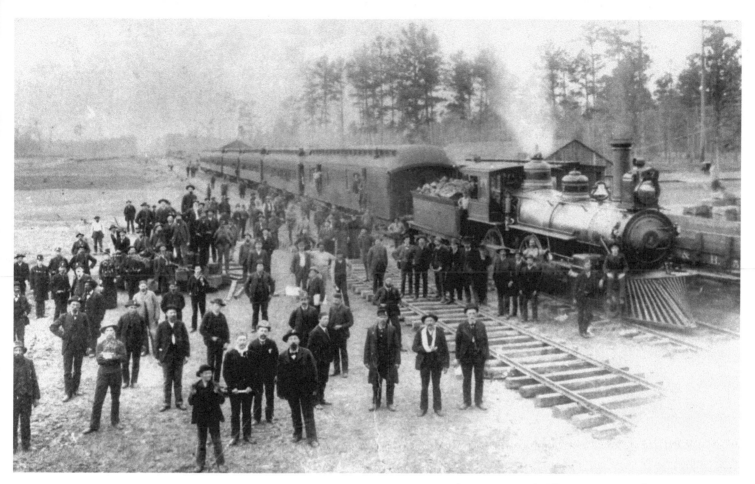

A passenger train idles near Birmingham in the 1880s.

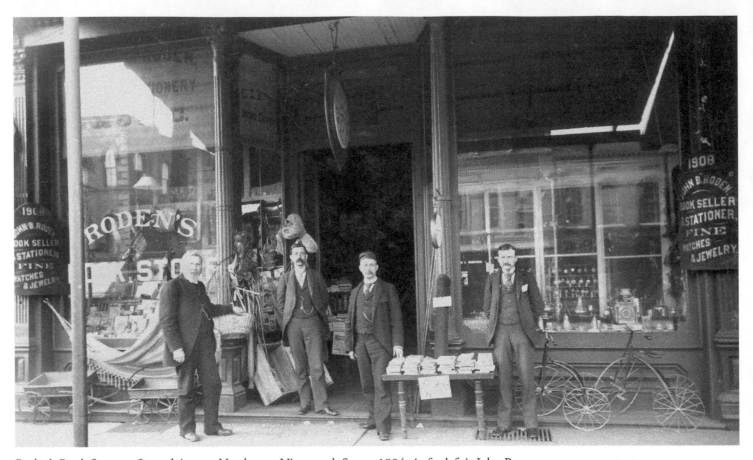

Roden's Book Store on Second Avenue North near Nineteenth Street, 1884. At far-left is John B. Roden, proprietor.

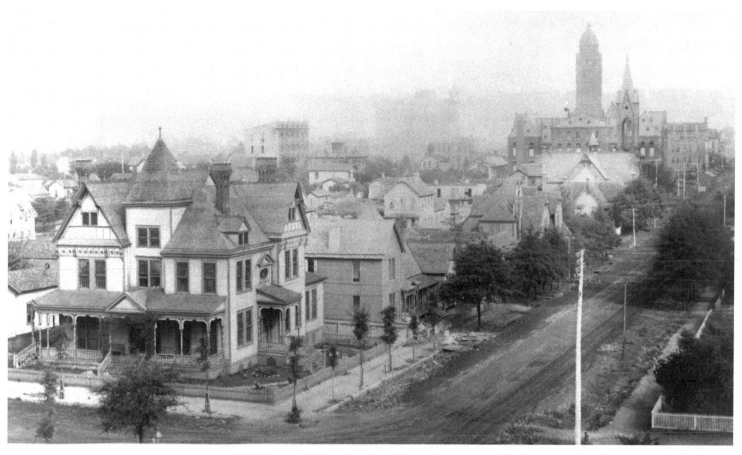

The home of Robert Jemison, Sr., on the corner of Sixth Avenue North and Twenty-first Street, around 1888. Jemison later moved to Glen Iris Park, an area he developed for his family and friends.

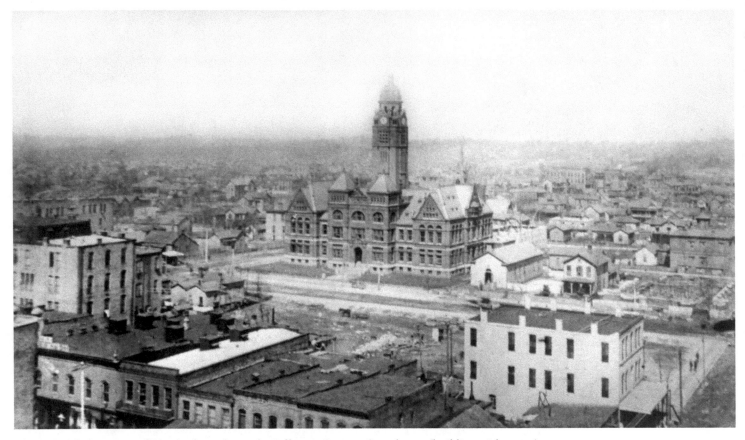

This 1890 skyline view of Birmingham shows the Jefferson County Courthouse (building with tower) on the corner of Twenty-first Street and Third Avenue North.

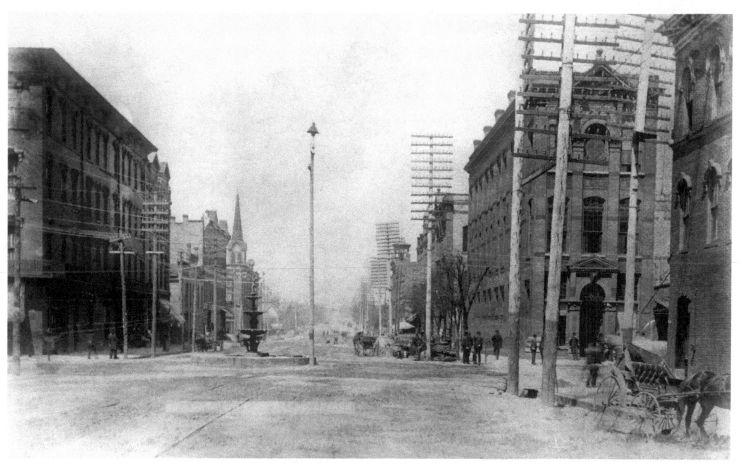

Nineteenth Street North at Second Avenue, around 1890. The fountain in the middle of the intersection was later removed and placed in storage, then lost.

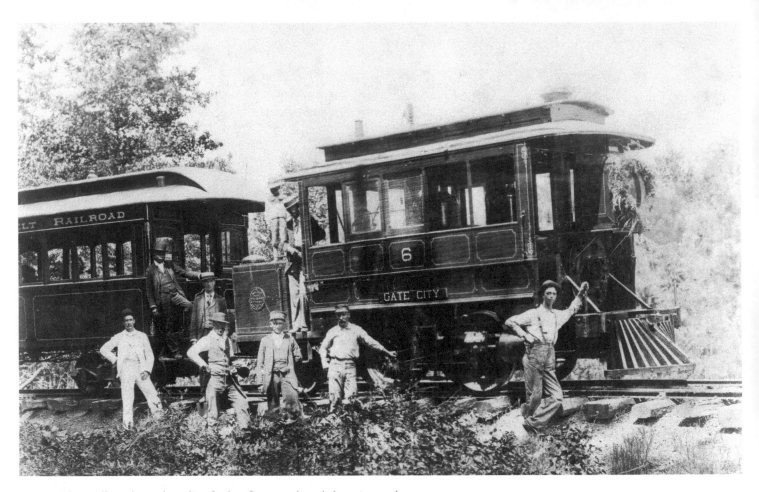

Streetcar lines allowed people to live farther from work and shopping and encouraged the development of Birmingham's first suburbs. Here an early Birmingham streetcar pauses on the tracks to Gate City, around 1890.

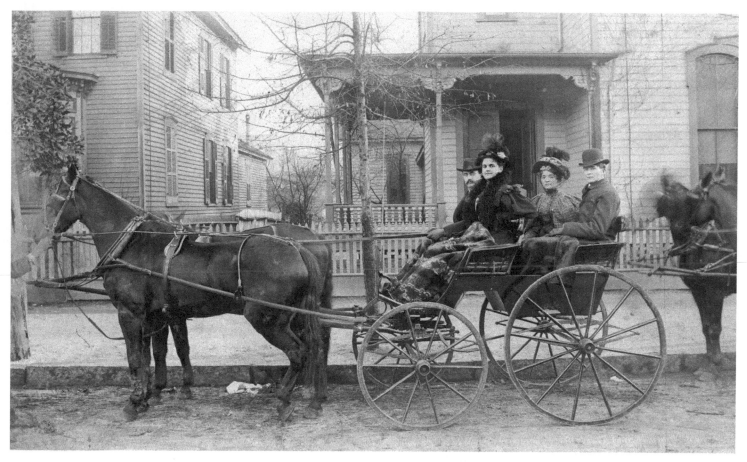

Going for a ride on Fifth Avenue in the late 1890s.

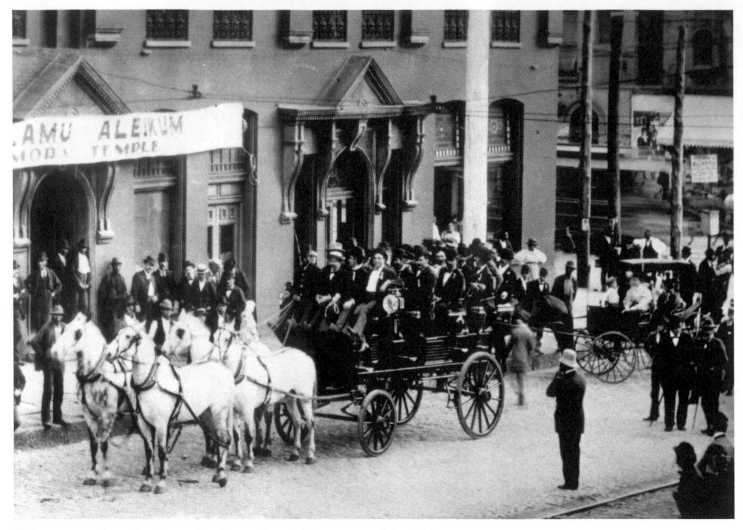

Shriners on parade, at First Avenue North near Twentieth Street, around the 1890s.

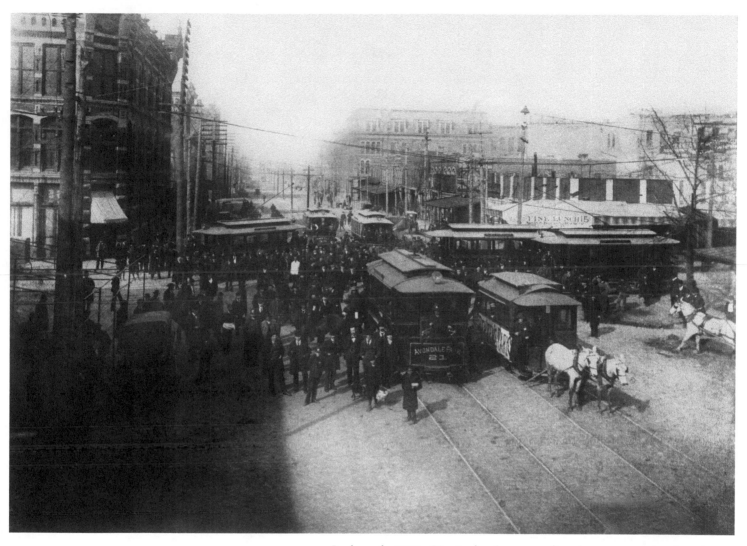

In the early 1890s, Birmingham's streetcar lines began converting from horse-drawn or mule-drawn to electric. Here, the two types of cars are shown on Twentieth Street.

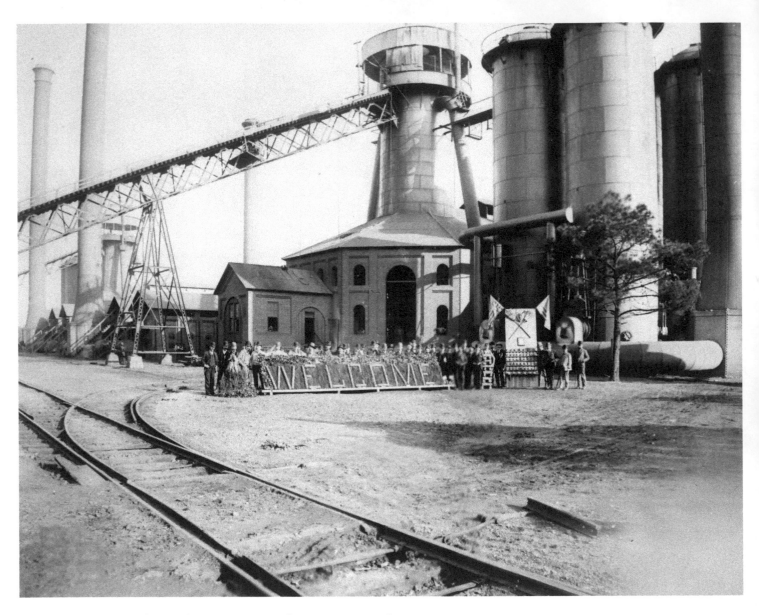

The Pioneer Mining and Manufacturing Company began operations of its blast furnace in Thomas in 1888. Republic Iron and Steel later assumed ownership and operated at the site until 1971.

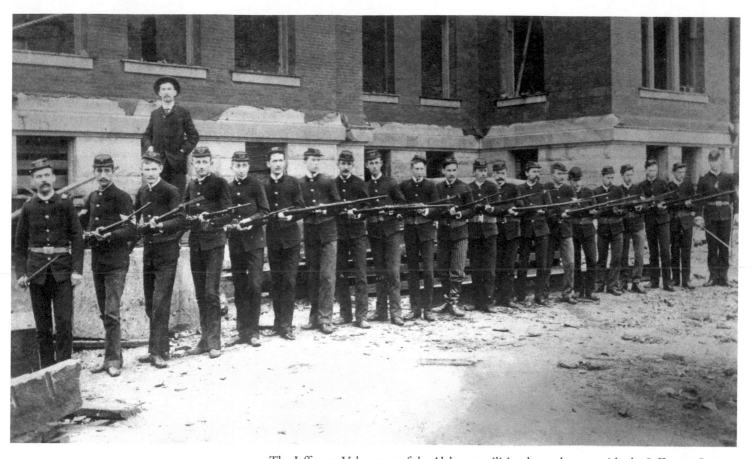

The Jefferson Volunteers of the Alabama militia, shown here outside the Jefferson County Courthouse, on December 8, 1888. On this date, the Volunteers were called out to help disperse a mob that attacked the courthouse trying to lynch Robert Hawes, a railroad engineer accused of murdering his wife and two daughters.

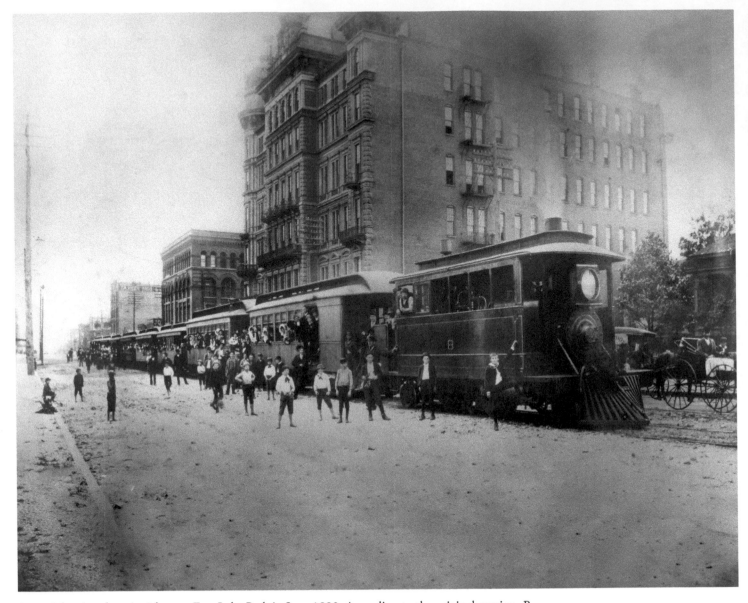

A special train takes picnickers to East Lake Park in June 1893. According to the original caption, B. H. Kelly was the train's engineer, Sherman Arrington the fireman, and Bob Baker and Charles Martin the conductors.

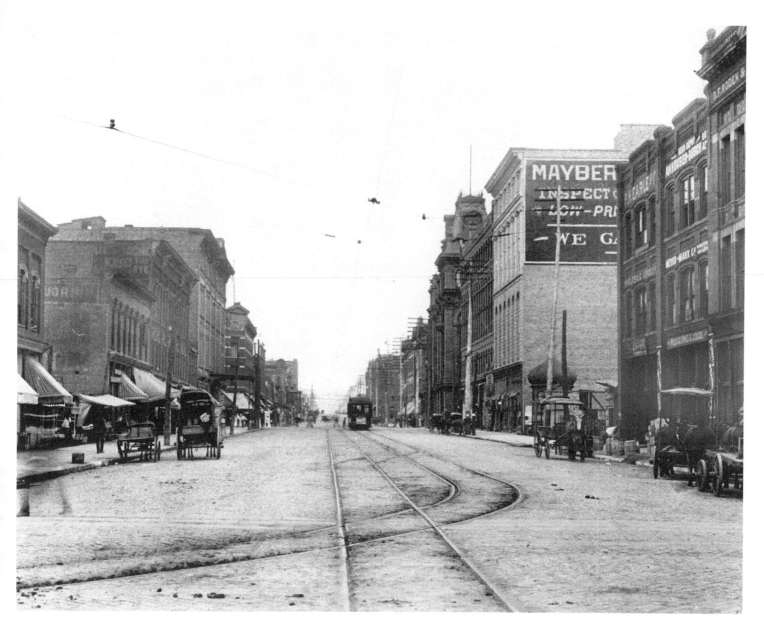

First Avenue North, facing east from Eighteenth Street, around the 1890s.

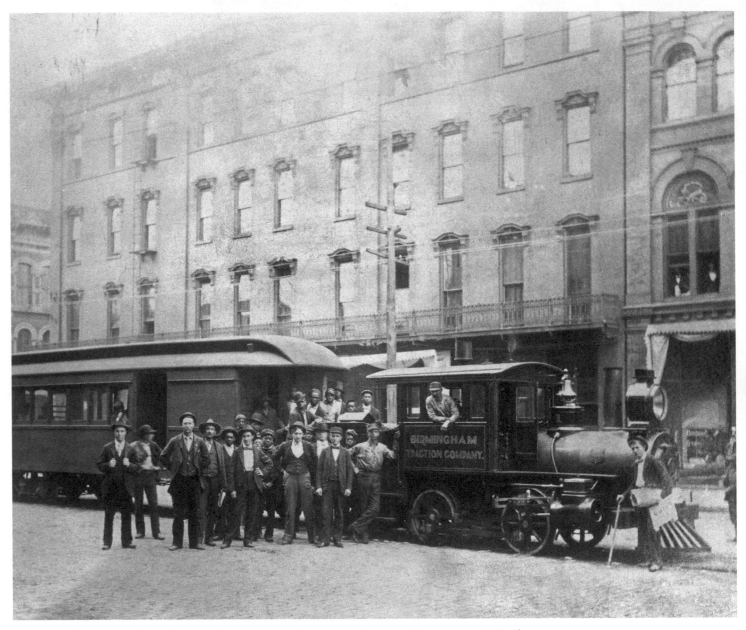

Streetcars of the Birmingham Traction Company carried passengers between downtown and North Birmingham in the 1890s.

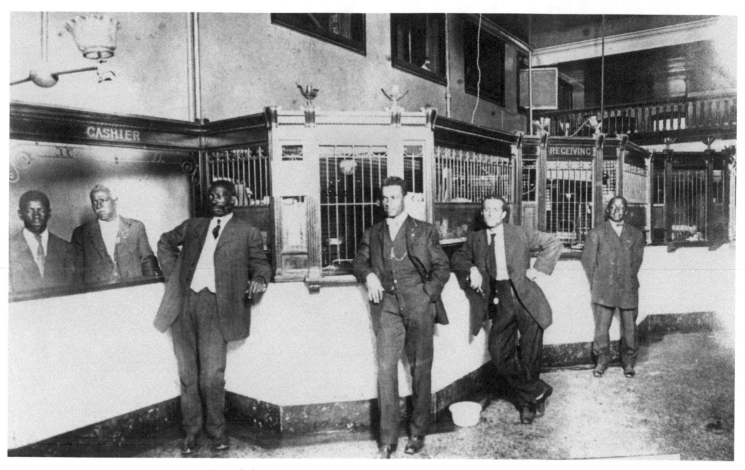

Founded in 1895 when most banks would not make loans to African-Americans, the Alabama Penny Savings Bank was Birmingham's first black-owned financial institution.

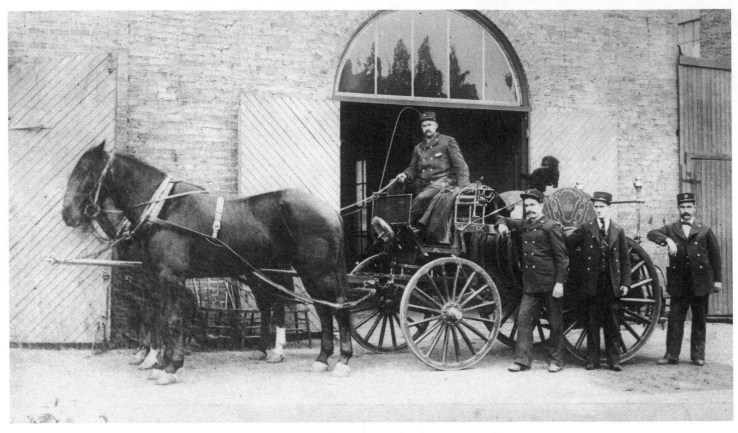

Members of the Birmingham Fire Department company number two pose for the camera at their station on Southside, around 1896.

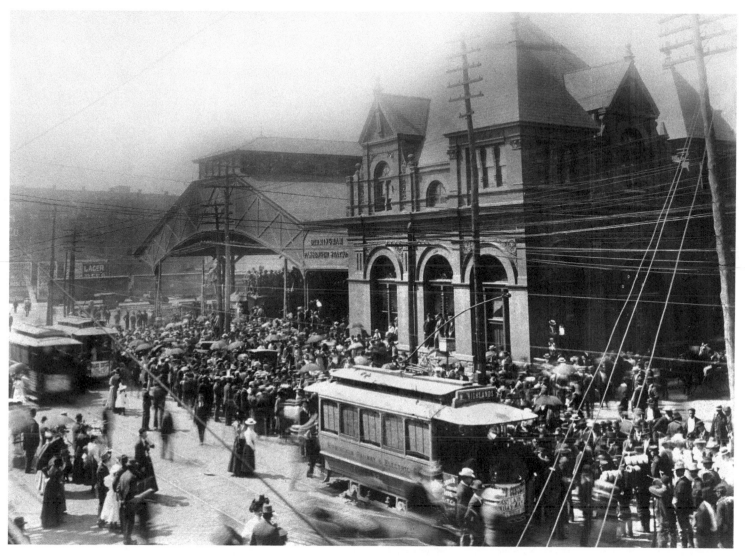

A crowd has gathered at Union Station on Twentieth Street to see local volunteers leave for the Spanish-American War, May 1, 1898.

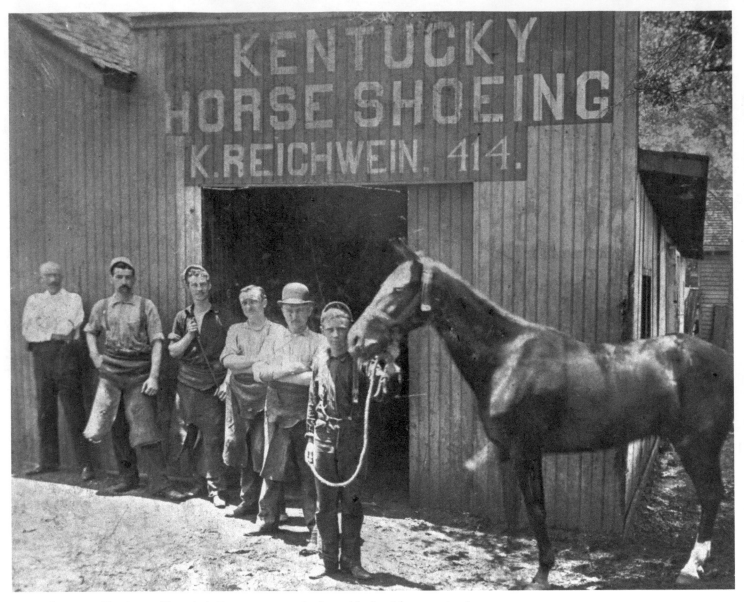

Kentucky Horse Shoeing on Twentieth Street was one of a dozen blacksmiths operating in Birmingham in the 1890s.

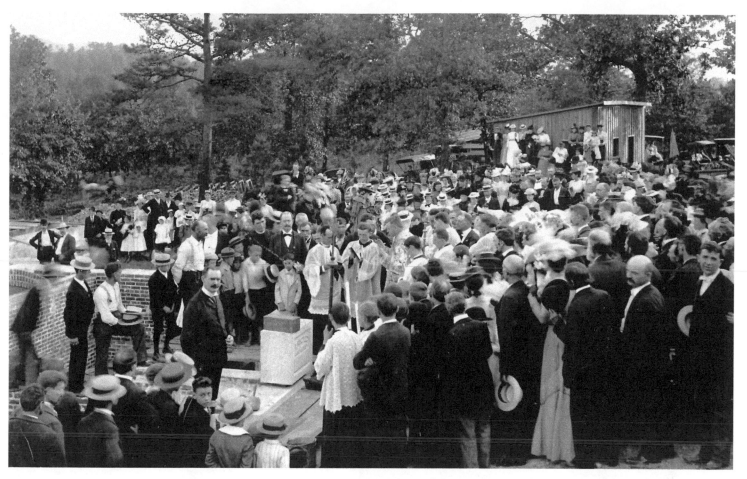

Laying of the cornerstone of St. Vincent's Hospital, May 30, 1899.

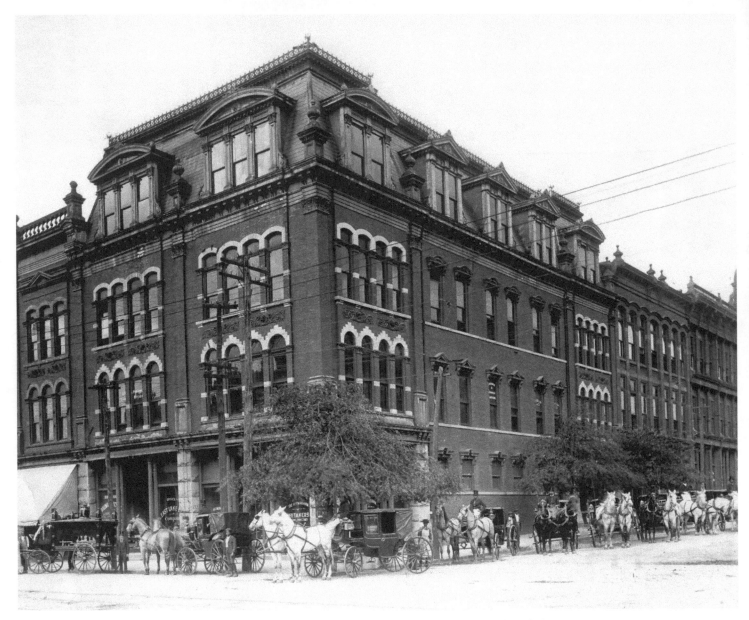

The old Watts Building, corner of Twentieth Street and Third Avenue North. Sometimes misidentified as the funeral procession for Louise Wooster, Birmingham's most famous madam, this photograph was made more than a decade before Wooster's death.

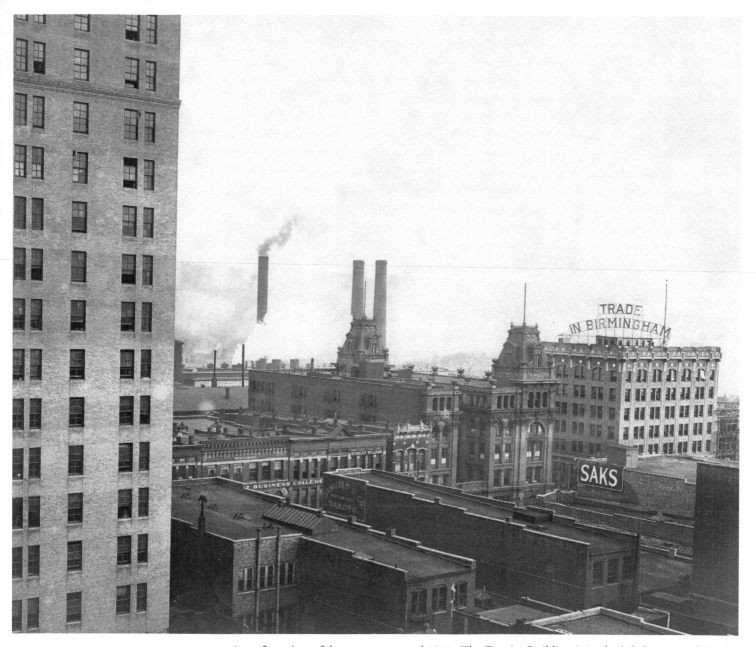

A rooftop view of downtown, around 1910. The Empire Building is in the left foreground. In the distance, with the "Trade in Birmingham" sign on the roof, is the old Chamber of Commerce Building on the corner of First Avenue North and Nineteenth Street. This is now Jemison Flats.

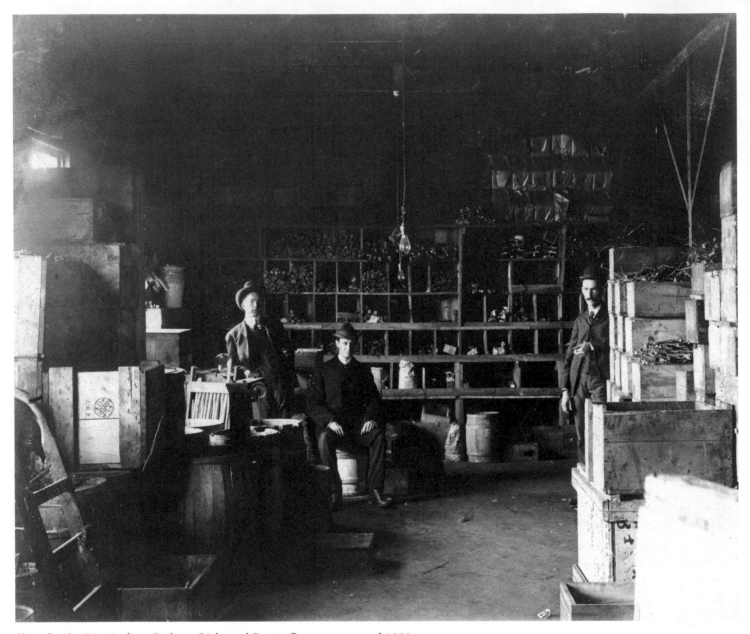

Shop for the Birmingham Railway, Light and Power Company, around 1900.

AT THE TURN OF THE CENTURY

(1900–1917)

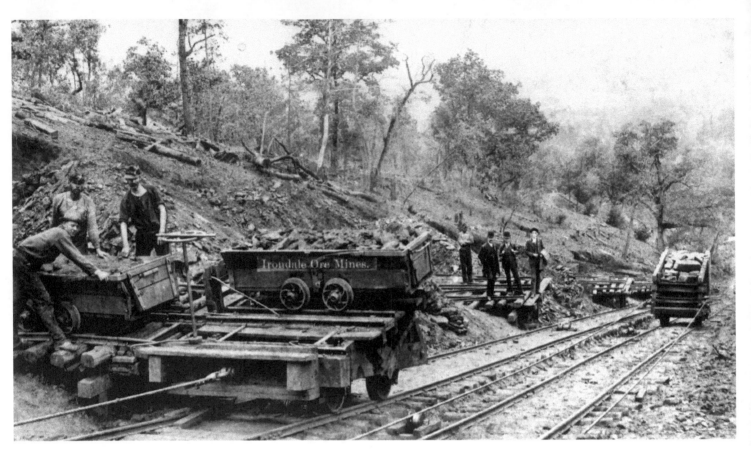

Outside the ore mines at Irondale, around 1900.

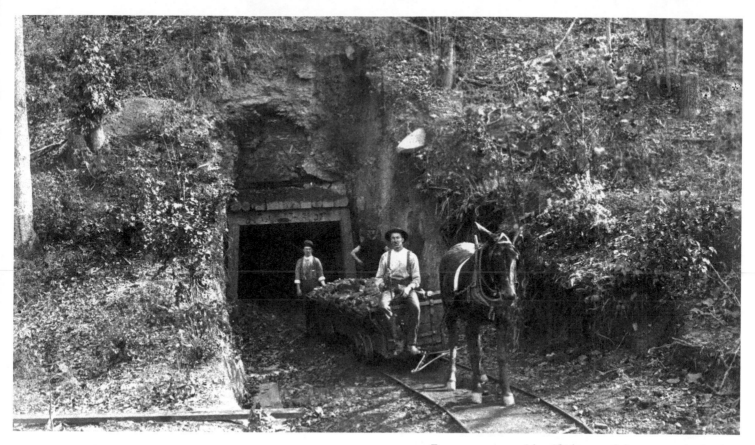

Entrance to an unidentified turn-of-the-century coal mine.

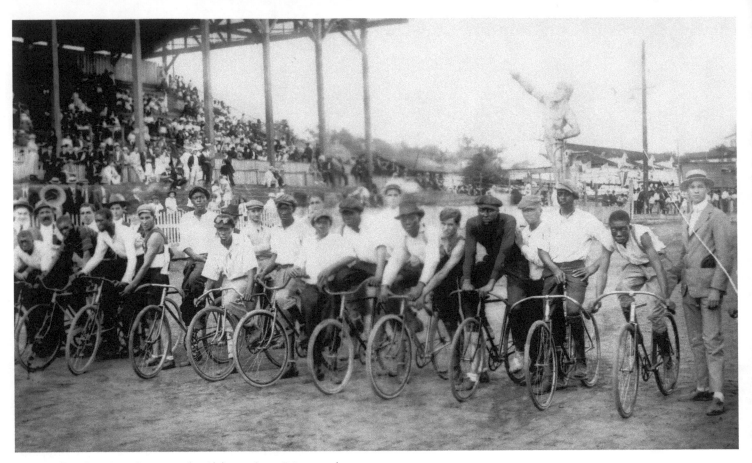

Starting line for a bicycle race at the Alabama State Fairgrounds.

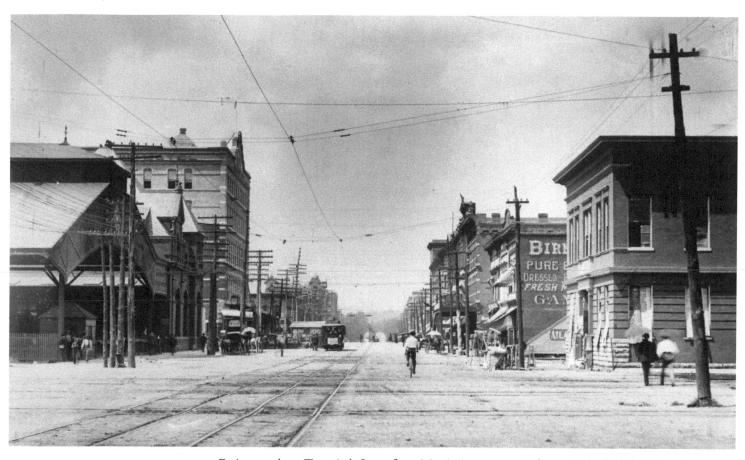

Facing north on Twentieth Street from Morris Avenue, around 1903. On the left is the train station with train shed and just beyond it the recently constructed Metropolitan Hotel.

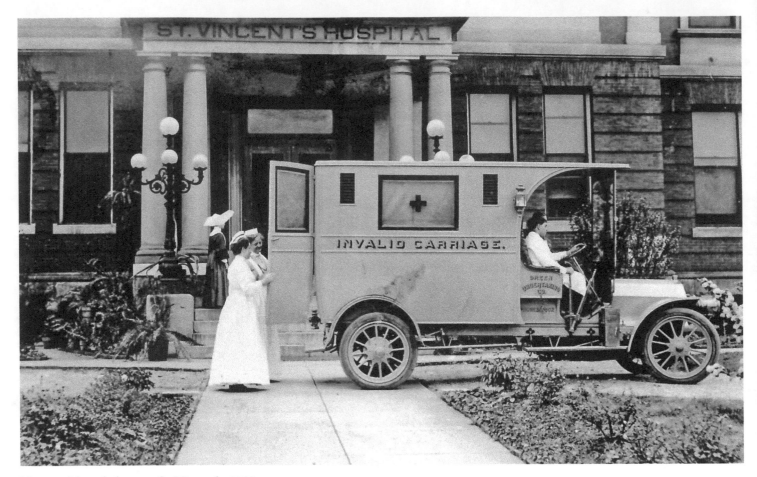

Nurses with ambulance at St. Vincent's, 1909.

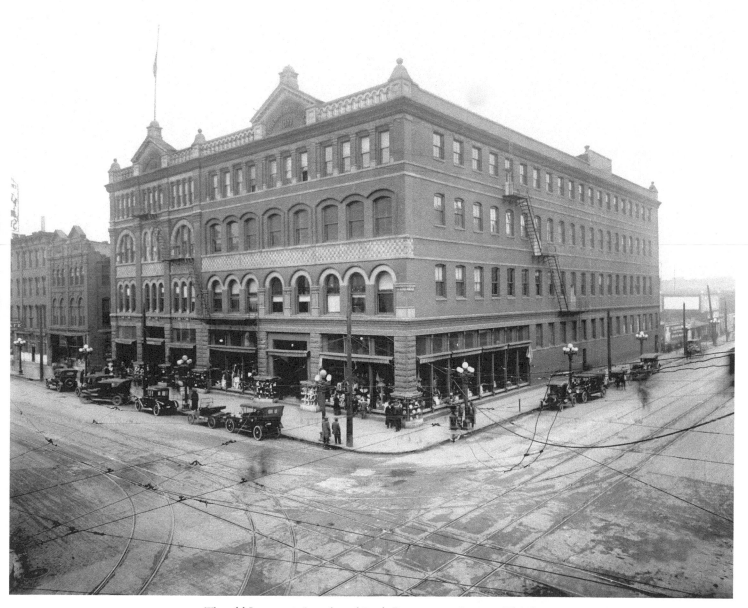

The old Loveman, Joseph and Loeb Department Store on Third Avenue North and facing Nineteenth Street. A few years after this photo was taken, the Alabama Theatre was built just past Loveman's on Third.

In the early twentieth century, motion pictures and Vaudeville shows were often promoted with elaborate displays like this one at the Lyric Theater.

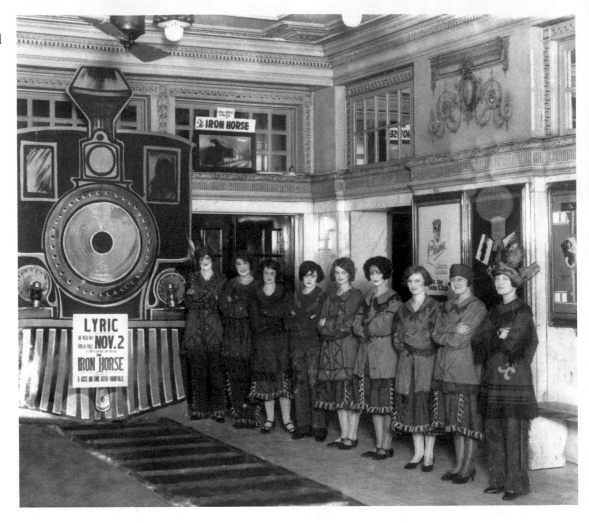

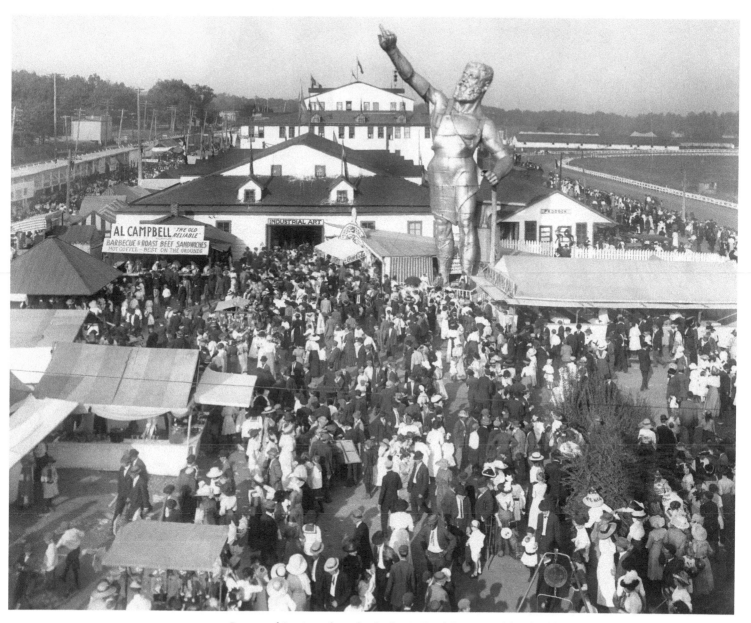

Between his triumph at the St. Louis World's Fair and his final home atop Red Mountain, Vulcan suffered a variety of indignities. Here he is shown at the state fair around 1910, assembled incorrectly so that his right arm is backward.

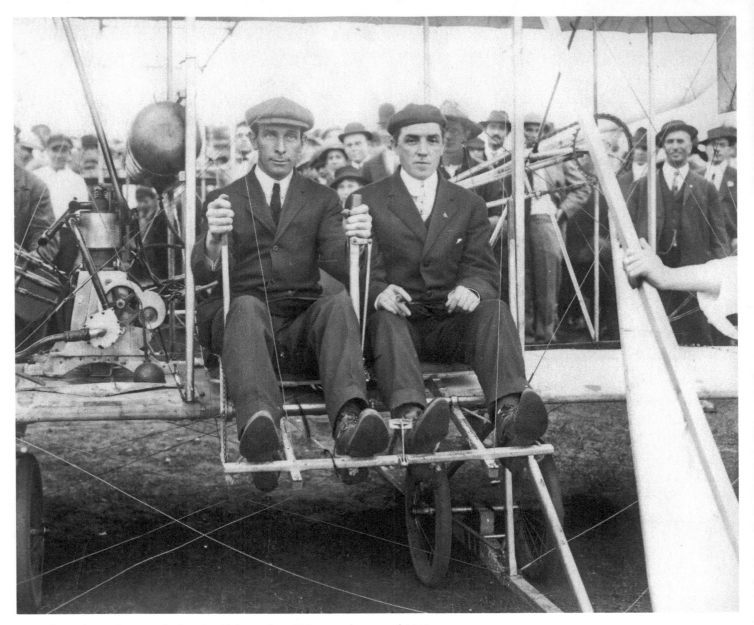

An early airplane, photographed at the Alabama State Fairgrounds, around 1910.

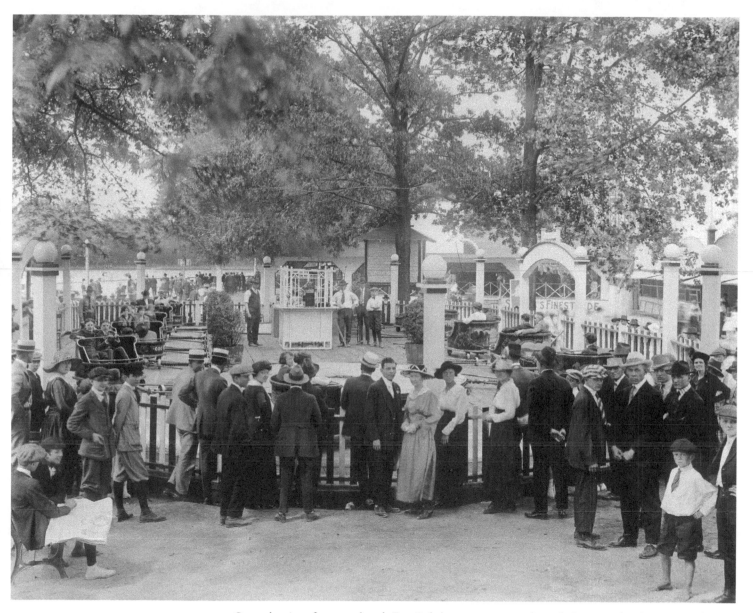

Once the site of a resort hotel, East Lake's amusement park made it a popular destination for day trippers in the 1910s.

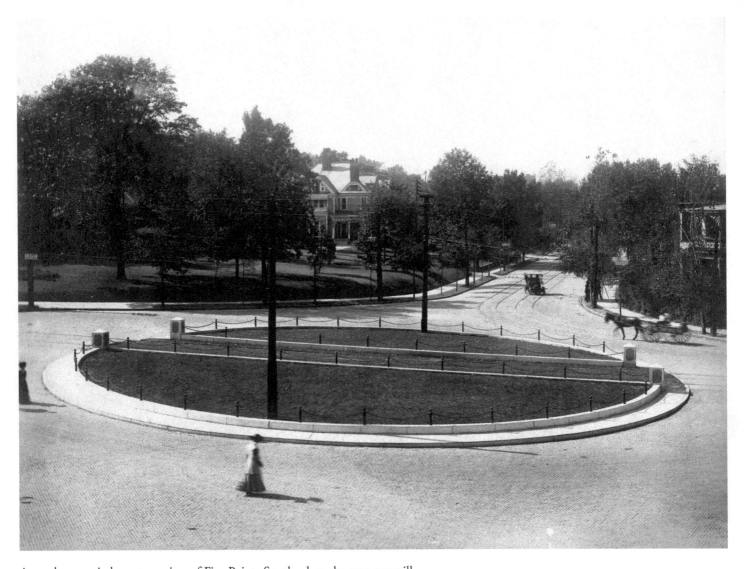

An early-twentieth-century view of Five Points South when the area was still largely residential. The cut intersecting the circle median is for the streetcar track.

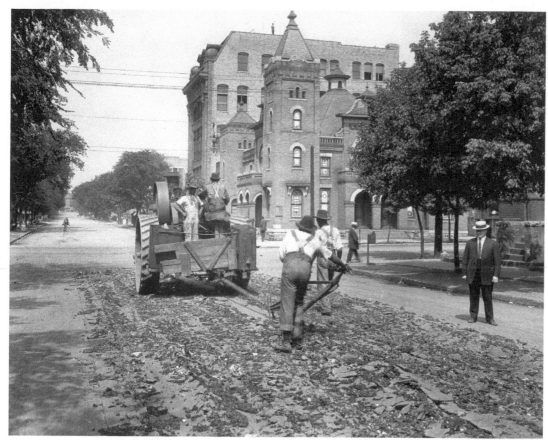

A road crew lays tracks for the Tidewater streetcar line along Fifth Avenue North in the spring of 1912. The church on the corner, First Christian, was later demolished, and the Redmont Hotel now occupies the site. The Birmingham Age-Herald building, visible just beyond, still stands.

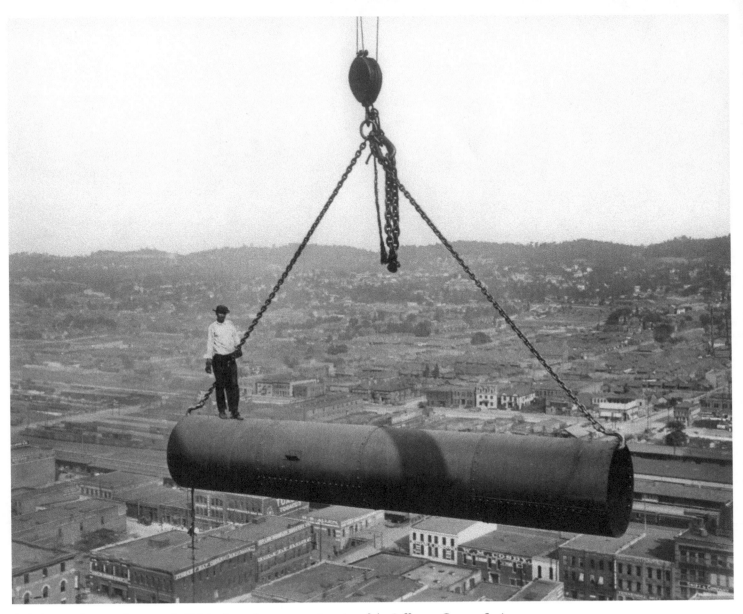

A daring worker stands suspended high above the construction site of the Jefferson County Savings Bank Building, around 1913.

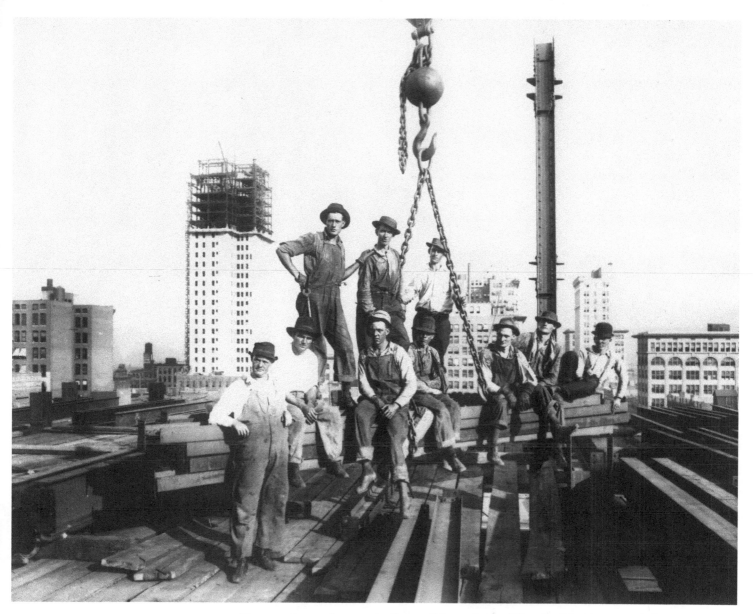

Construction workers on the frame of the unfinished Tutwiler Hotel, 1913. Under construction behind them is the Jefferson County Savings Bank Building, now the City Federal Building.

The Tutwiler, for decades Birmingham's finest hotel, was located on the corner of Fifth Avenue North and Twentieth Street (now the location of Regions Bank). Built in 1914, the hotel was demolished in 1974, one of the first buildings in the United States to be imploded.

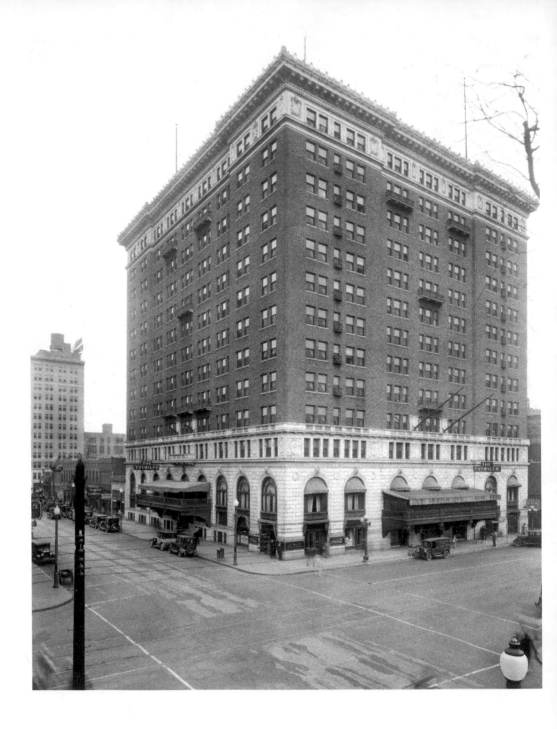

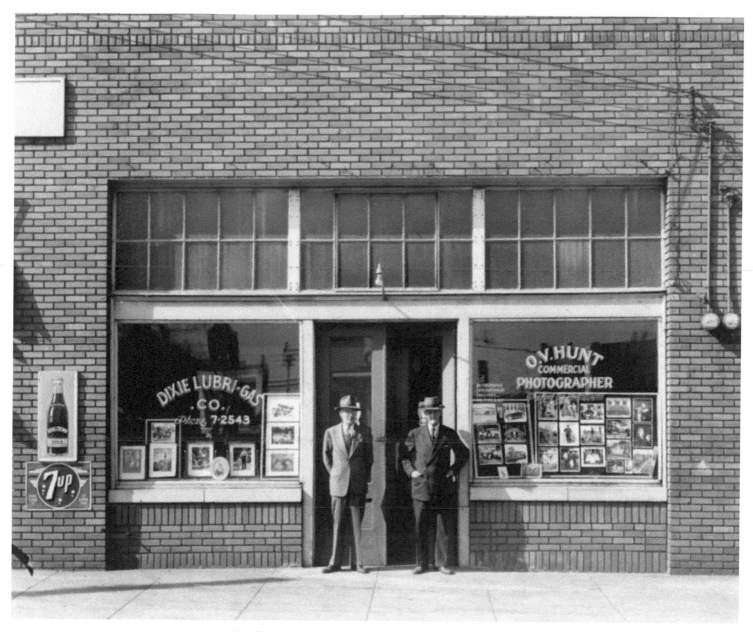

Studio of O. V. Hunt, Birmingham's best-known early commercial photographer. Hunt took many of the photographs featured in this book.

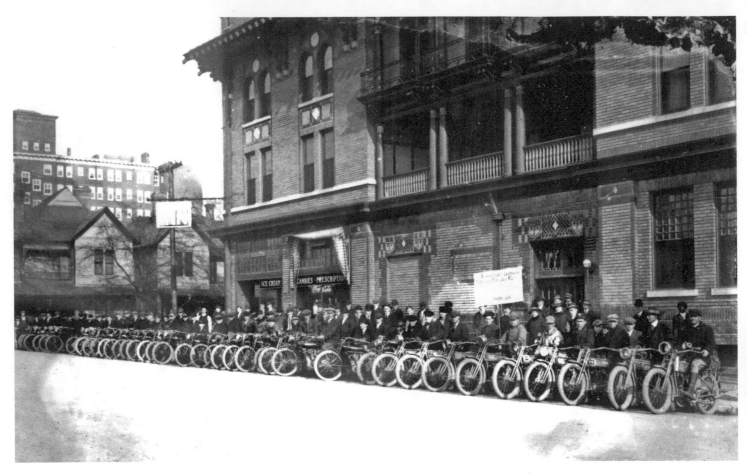

Motorcyclists along Seventh Avenue North, around 1915. The Ridgley Apartments building, now the Tutwiler Hotel, is visible at upper-left.

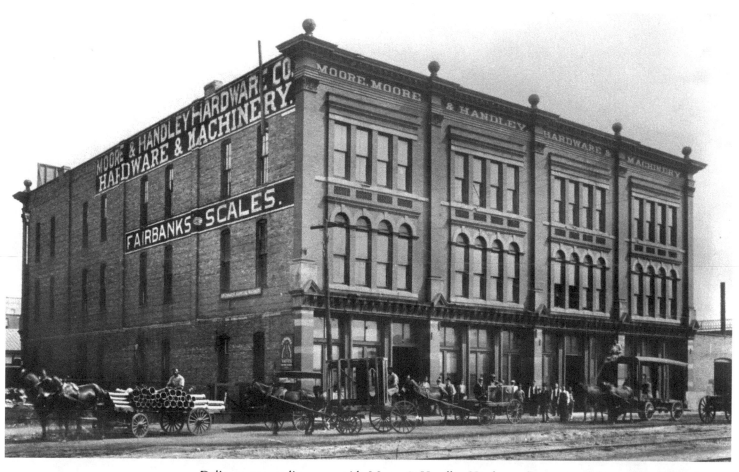

Delivery wagons line up outside Moore & Handley Hardware Company, at the corner of First Avenue North and Twentieth Street, around 1915.

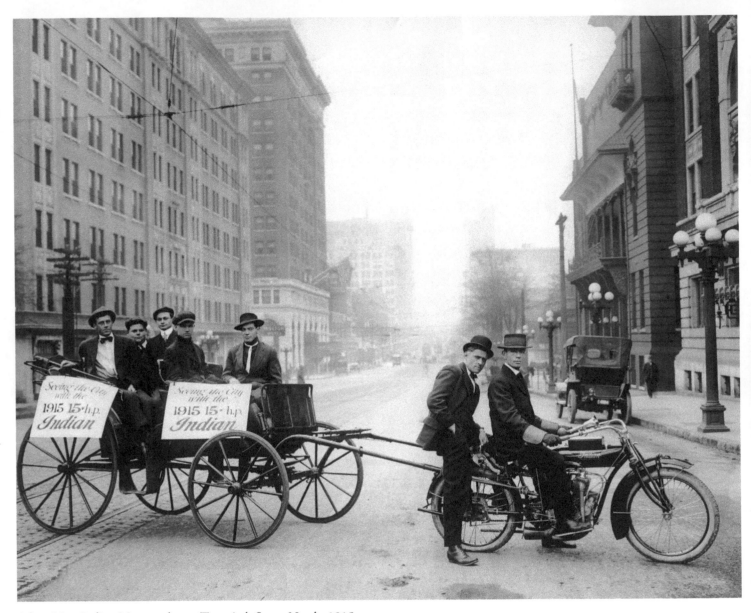

Advertising Indian Motorcycles on Twentieth Street North, 1915.

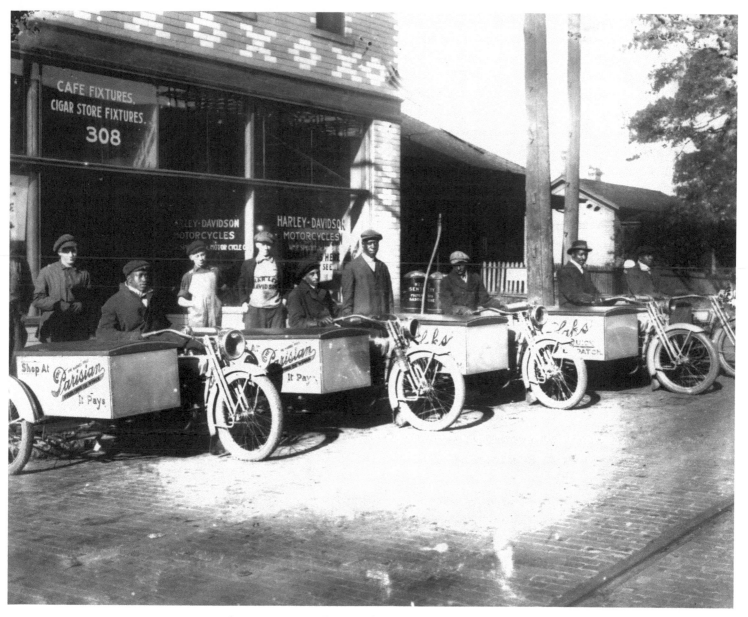

Delivery men on Harley-Davidson motorcycles. This photo was taken sometime after 1914, the first year that Harley-Davidson offered bikes with sidecars.

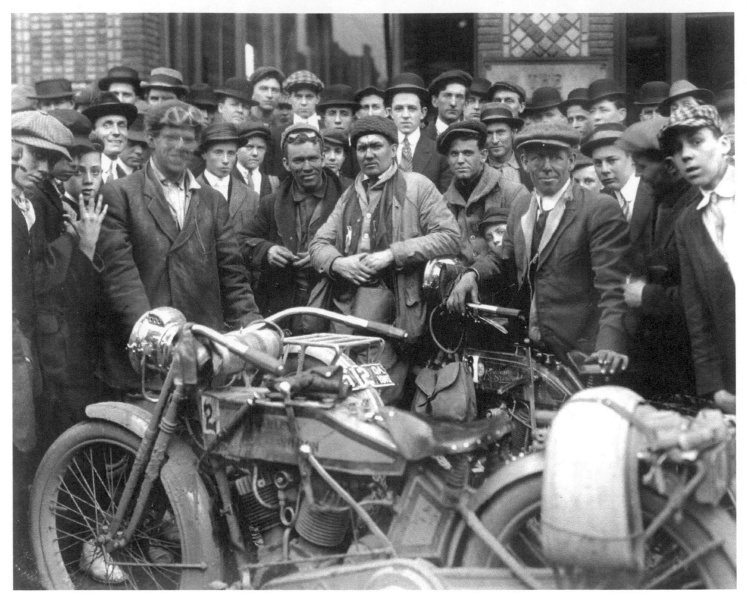

Motorcyclists gather, probably for a race, in front of the Birmingham Ledger Building, around 1915.

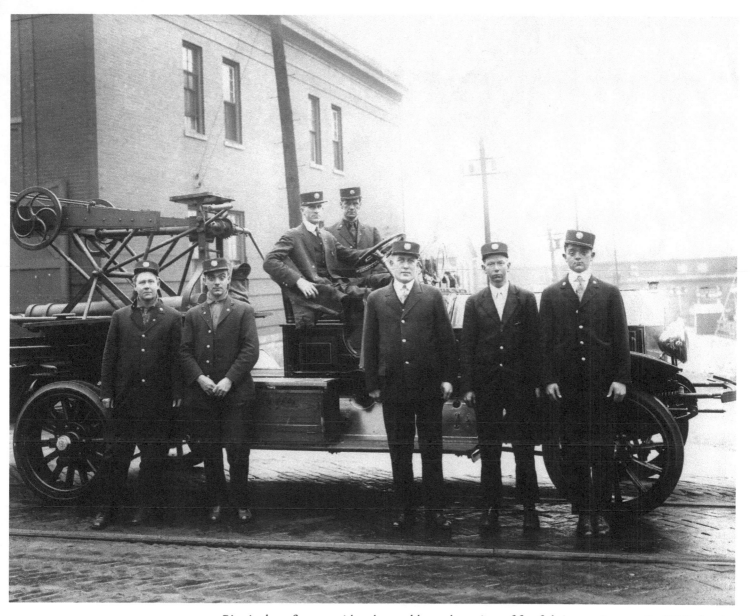

Birmingham firemen with a thoroughly modern piece of fire-fighting equipment. In 1916, the city replaced horse-drawn fire wagons with "motordrawn pumps."

Confederate Veterans held four reunions in Birmingham in 1894, 1908, 1916, and 1926. Here in 1916, two veterans enjoy the hospitality of the White Swan Laundry.

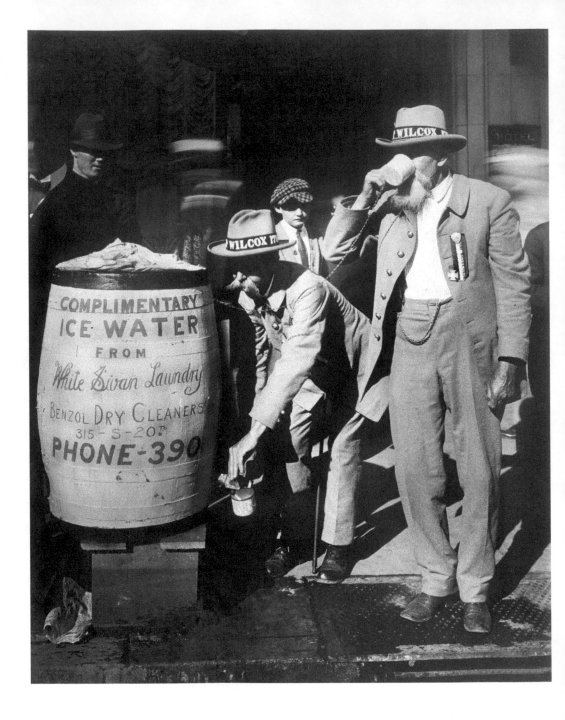

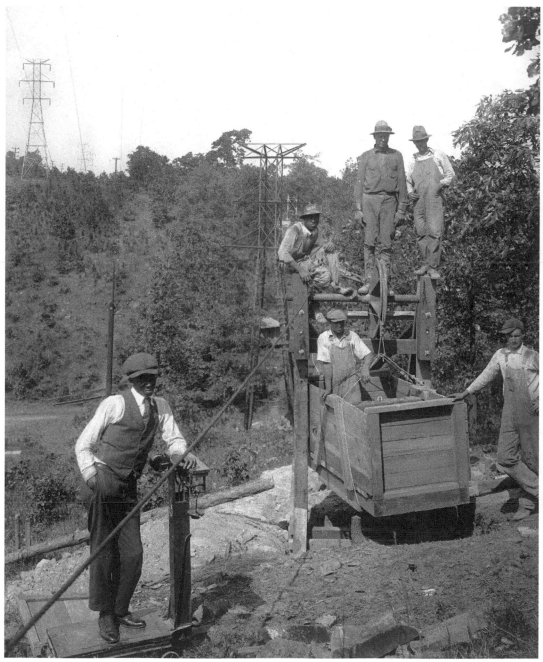

Transmission line workers of the Bessemer, Warrior line demonstrate the method of stringing electrical lines on towers, May 5, 1918. Transmission lines from Lay Dam and Gorgas Steam Plant came to substations in Bessemer and Birmingham. From the transmission substations, lines went to distribution substations throughout the area and from there to businesses, homes, and industries.

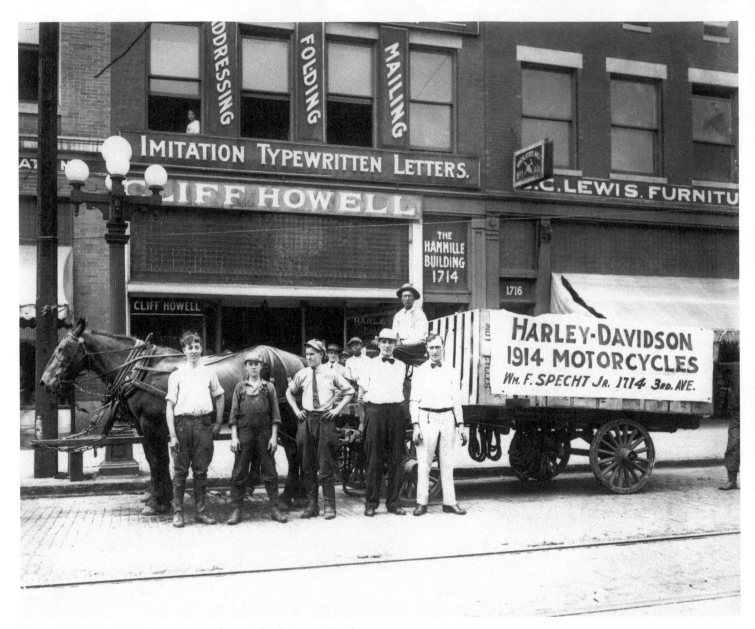

Promoting Harley-Davidson motorcycles on Third Avenue North.

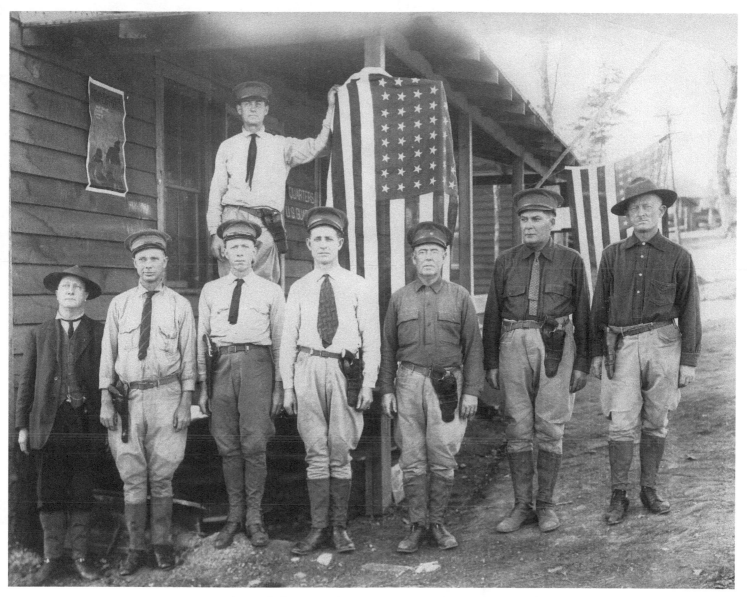

U.S. Marshals stationed at Warrior Reserve (Gorgas) Steam Plant during World War I, 1918. When World War I broke out, the U.S. government contracted with Alabama Power Co. to construct a second generating unit at its Warrior Reserve Plant and build a 90-mile transmission line to Muscle Shoals to supply electricity to a nitrates plant under construction there. The nitrates plant was commissioned to manufacture munitions for the war effort.

Second Avenue North at
Nineteenth Street, decorated for
the state fair.

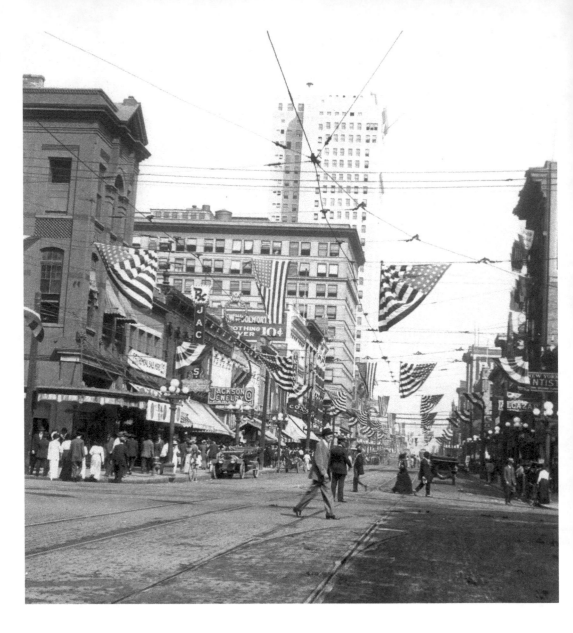

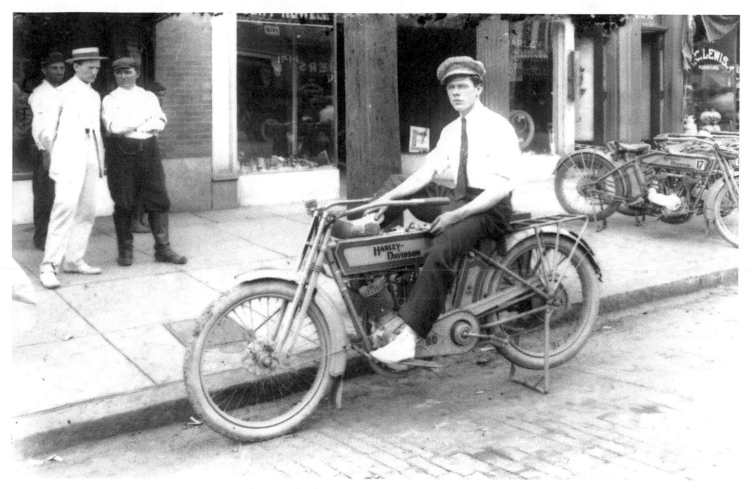

Harley-Davidson motorcycles outside Cliff Howell's bicycle repair shop, Nineteenth Street North.

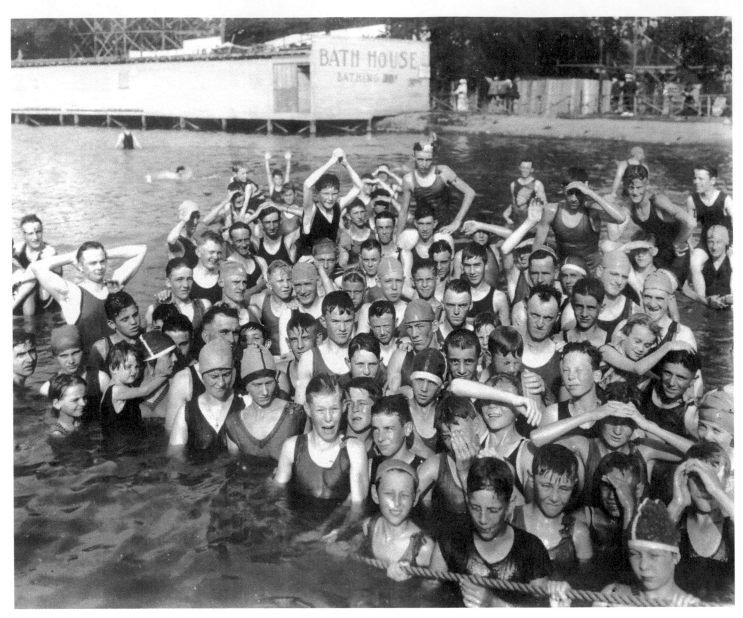

Swimming at East Lake Park.

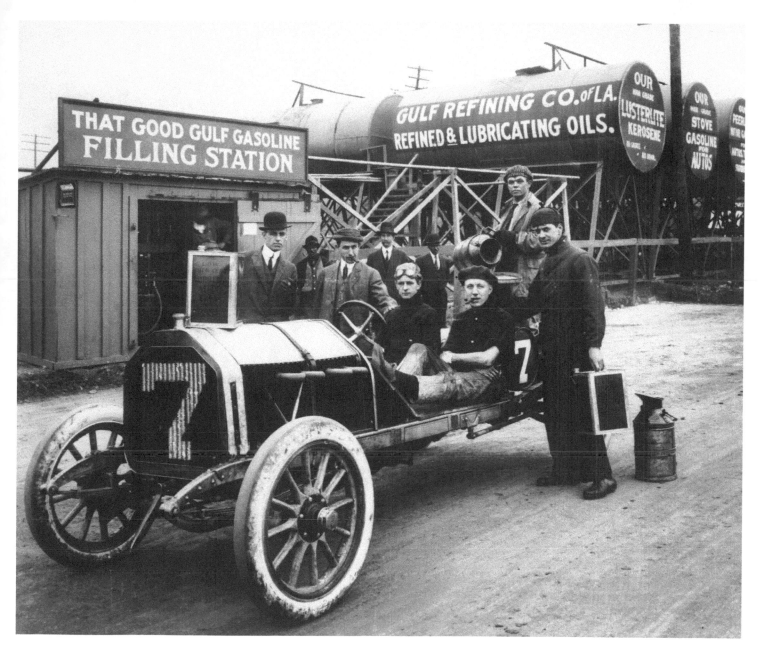

Drivers and crew for an early auto race, 1918.

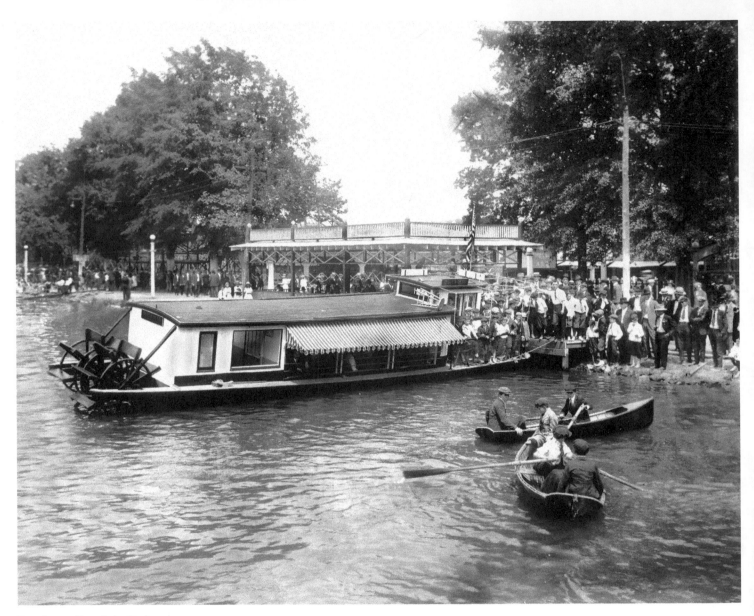

Boating at East Lake Park.

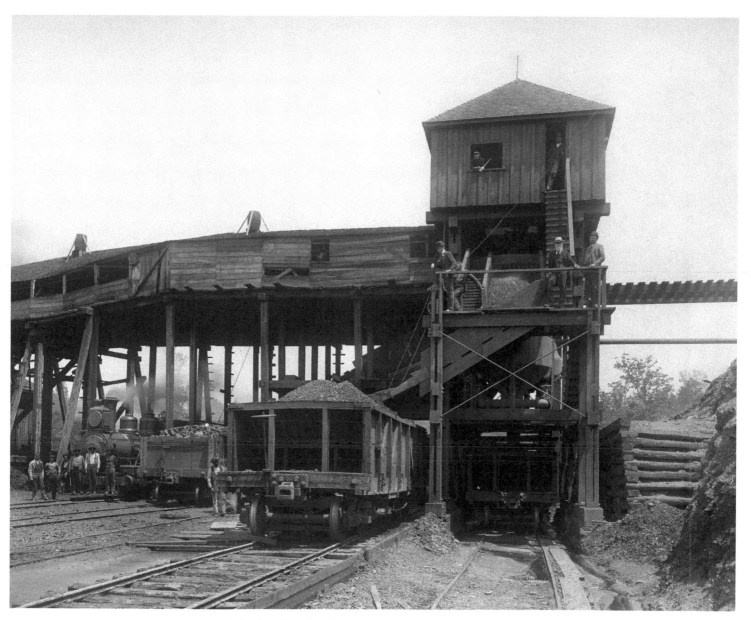

A tipple, where freight cars coming out of the mine were emptied, at the Tennessee Coal, Iron and Railroad Company's Pratt Mines.

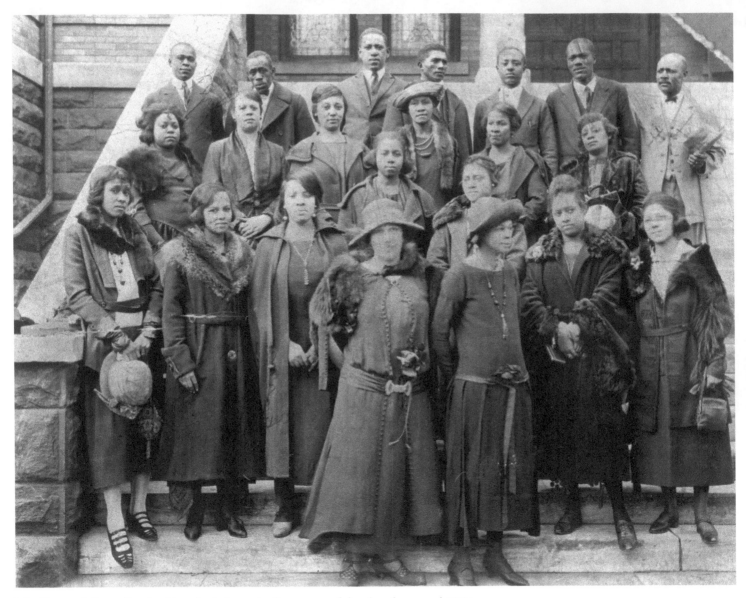

The Sixteenth Street Baptist Church choir on the front steps of the church, around 1917.

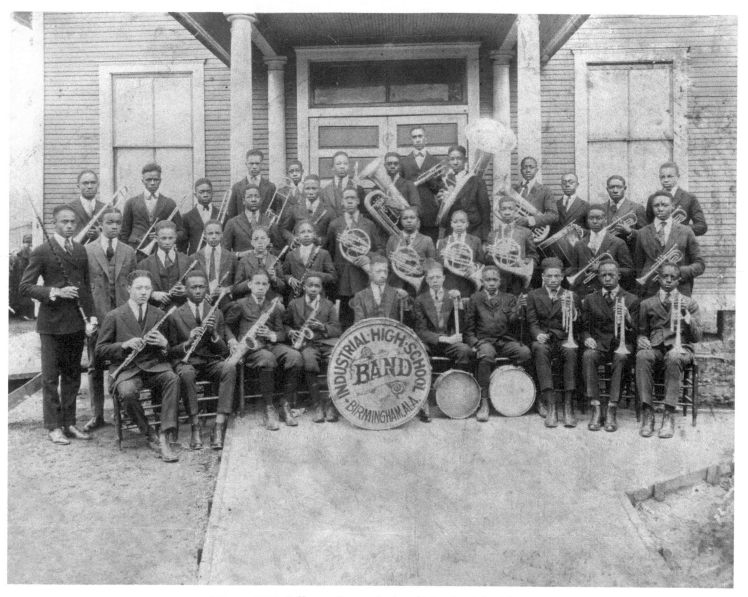

Prior to 1900, Jefferson County had no high school for African-Americans. Responding to calls from parents, Industrial High was established and A. H. Parker was named its principal. Meeting first in one room, then in a series of shotgun shacks, then an old theater, the school constructed a building in 1924 on the corner of Eleventh Street and Eighth Avenue North. Later renamed to honor Dr. Parker, the institution became the largest high school for blacks in the South.

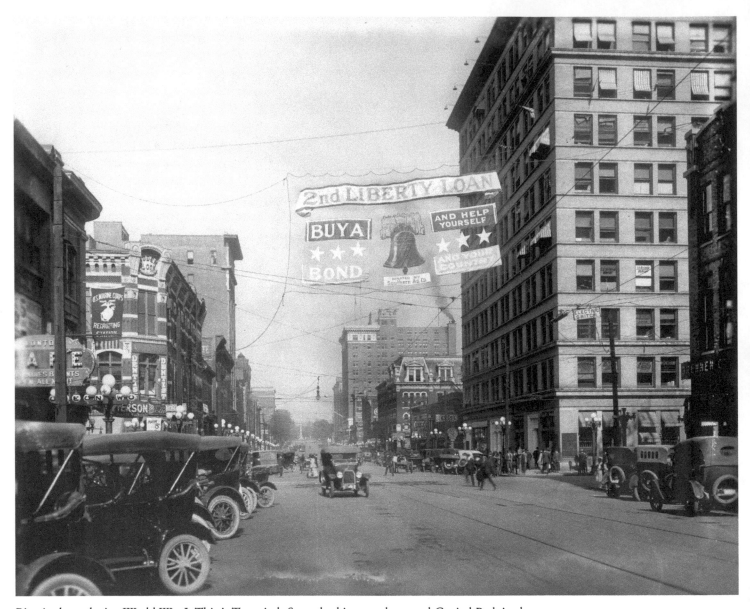

Birmingham during World War I. This is Twentieth Street looking north toward Capital Park in the distance (now Linn Park).

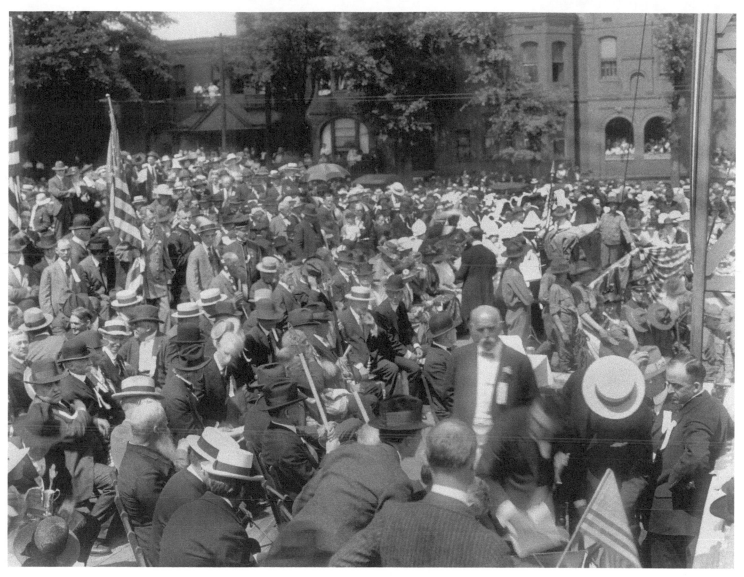

Laying of the cornerstone for the downtown post office, around 1918. This building would replace the older nineteenth-century post office on Second Avenue North, and is now used as a federal courthouse.

Standing on the corner of First Avenue North and Twentieth Street, the Empire Building was completed in 1909. It is shown here around 1918.

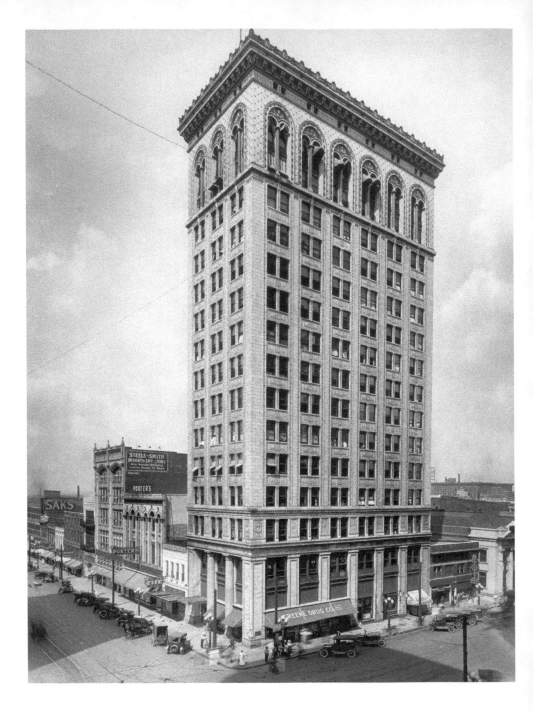

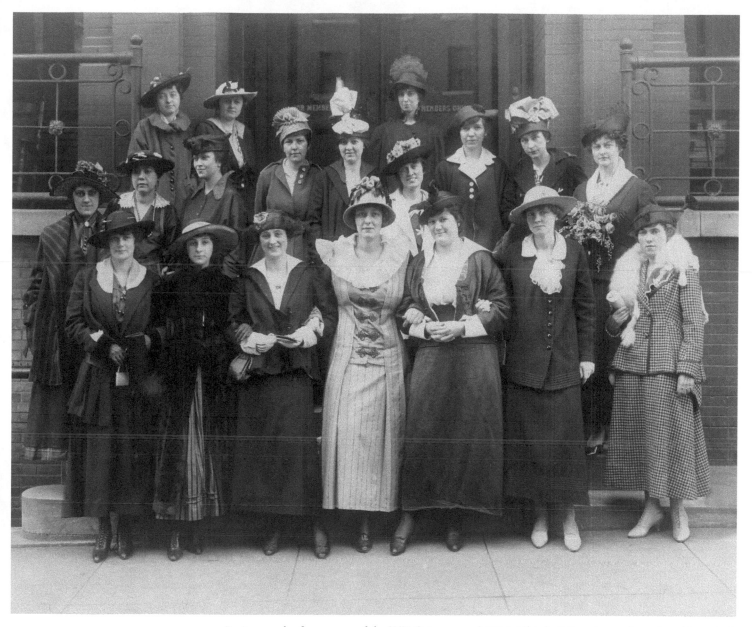

Posing on the front steps of the Y.W.C.A., around 1918. This building, located on short Twentieth Street North, facing Capital Park (now Linn Park), was demolished in the 1950s to make way for Birmingham's current city hall.

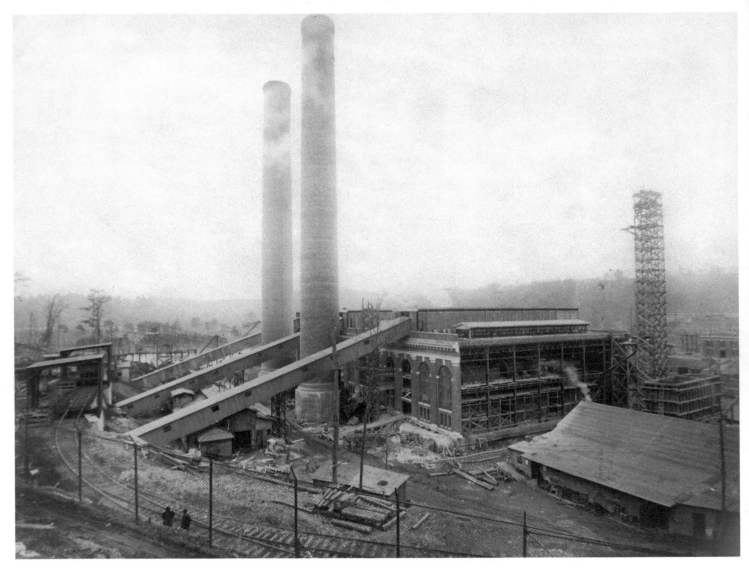

Warrior Reserve Steam Plant was later renamed in honor of William Crawford Gorgas. Located in Parrish near Birmingham, this image shows unit #2 under construction, December 10, 1918. Gorgas was the second steam plant constructed by Alabama Power Co. It was originally developed to serve as reserve or "back-up" power for the company's hydroelectric plants on the Coosa and Tallapoosa rivers. Electricity from these plants supplied wholesale power to the Birmingham Electric Co. until the two companies merged in 1952.

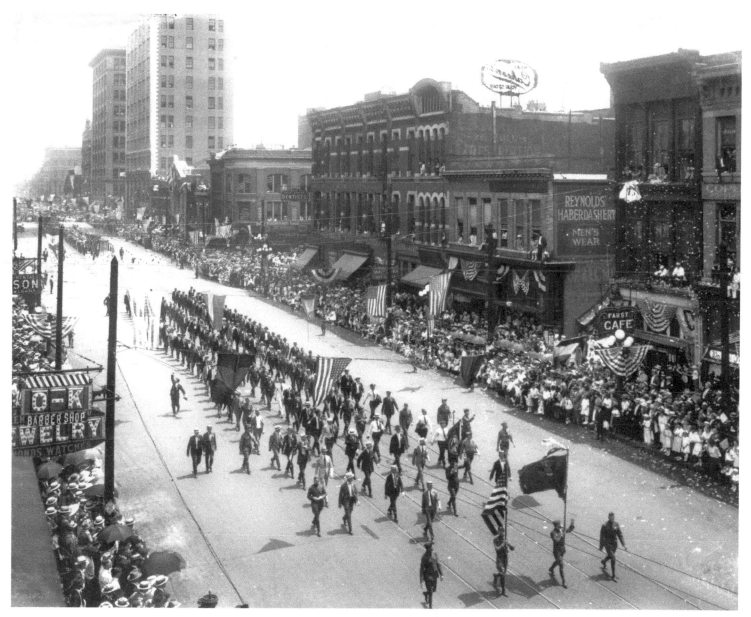

A parade down Twentieth Street honors World War I veterans of the Rainbow Division in 1919.
Unlike earlier wars, in which military units were made of men from the same state or town, the
Rainbow Division included men from 26 states, including Alabama, and saw extensive combat.

Providing drivers with some direction on Twentieth Street North in the 1920s.

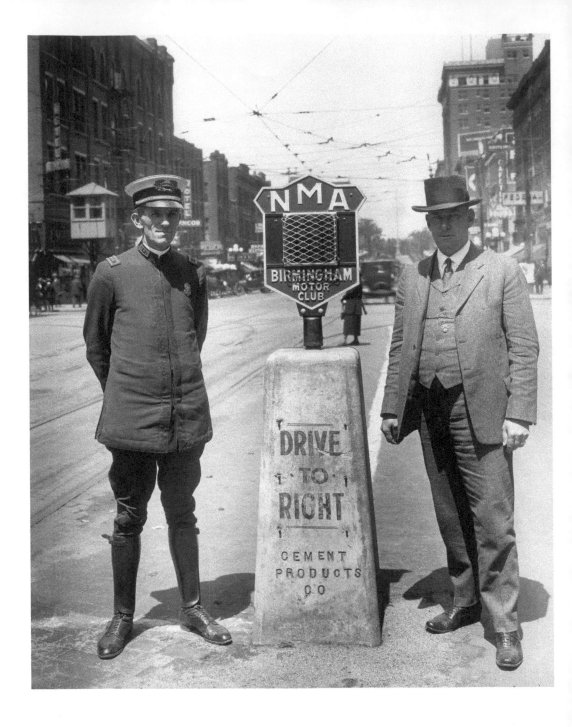

A Growing Metropolis and a Great Depression

(1918–1939)

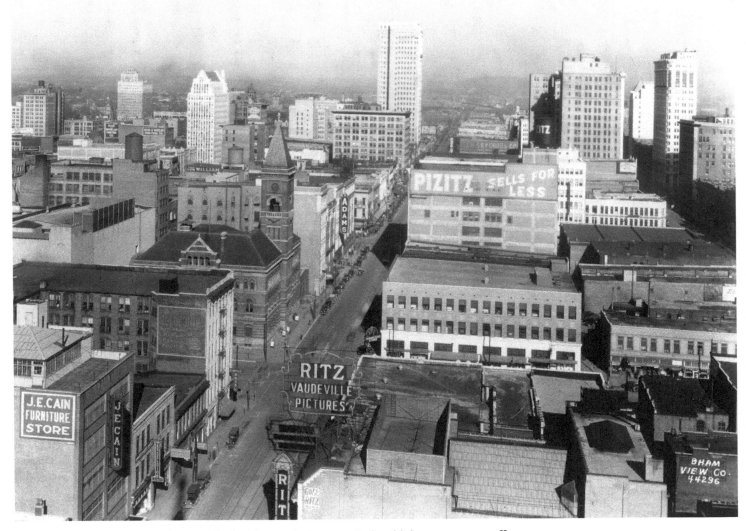

Second Avenue North around 1920. The building with the tower is the old downtown post office on the corner of Eighteenth Street.

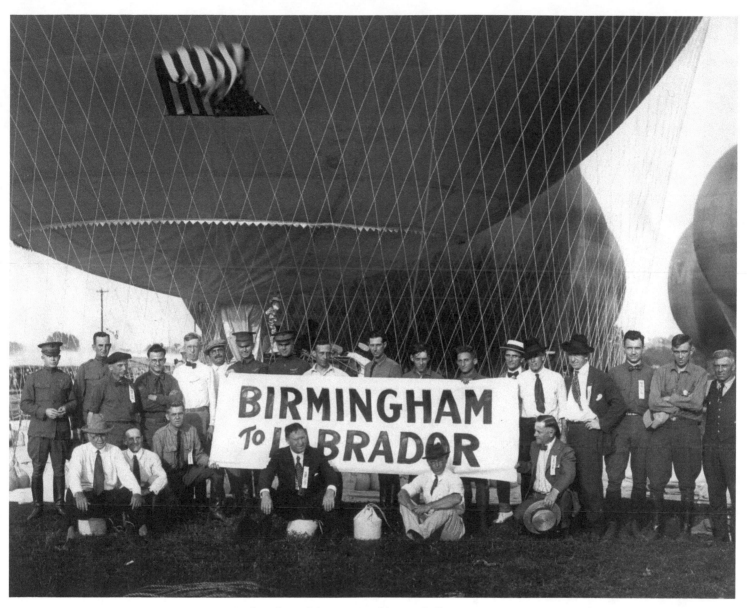

Birmingham hosted three national hot-air balloon races in 1920, 1921, and 1934. Here pilots and local sponsors pose with the line of balloons before take-off in 1920. The winner would be the balloon that made it farthest, because none made it all the way to Labrador.

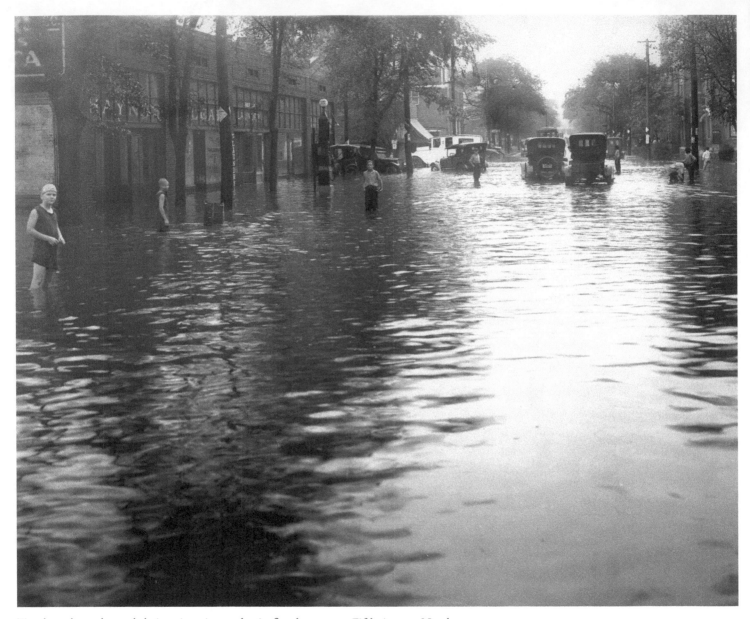

Two boys have donned their swimsuits to play in floodwaters on Fifth Avenue North.

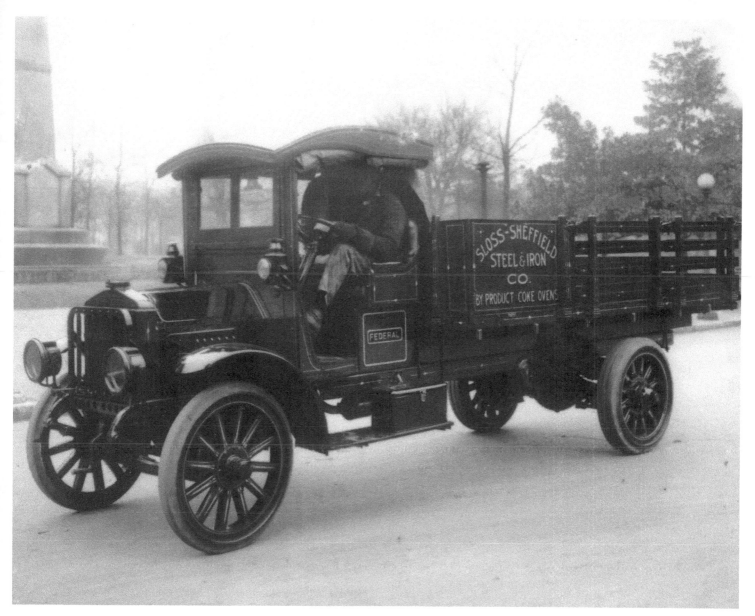

A Sloss-Sheffield truck is parked beside Woodrow Wilson Park (now Linn Park).

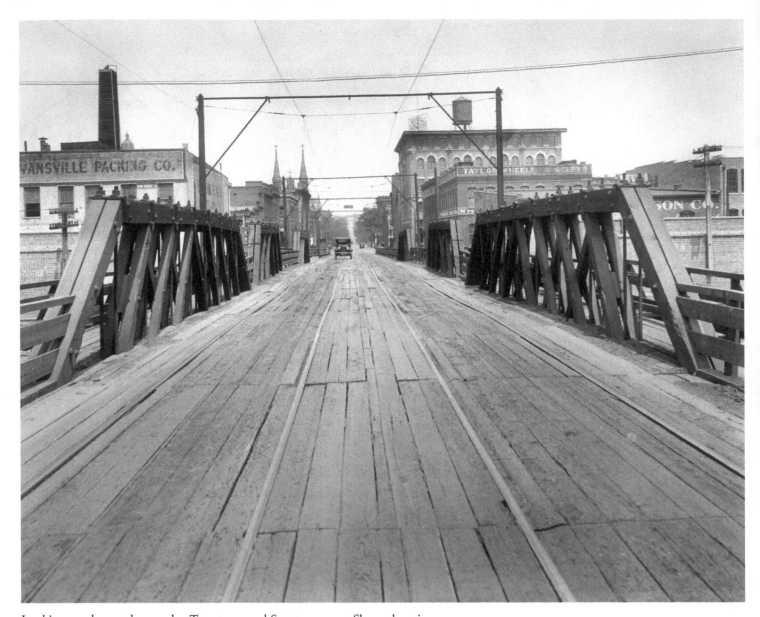

Looking north over the wooden Twenty-second Street overpass. Shown here in the 1920s, the bridge was built in the 1890s to carry streetcars over the railroad reservation.

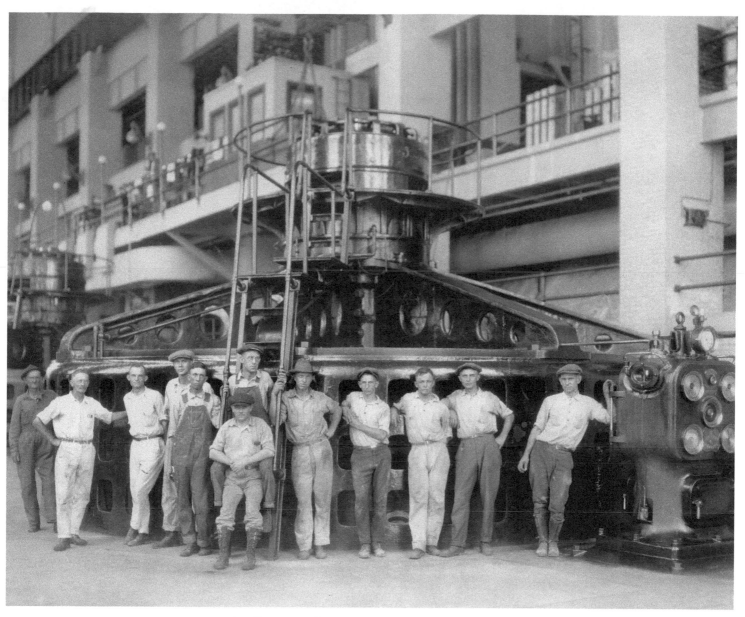

Lay Dam powerhouse crew, around 1920. Lay Dam was the first hydroelectric plant constructed by Alabama Power Company and was the first step in W. P. Lay's, James Mitchell's, and Thomas W. Martin's vision of creating an interconnected system of hydro and steam plants that would provide safe, reliable, and economical electricity—not only to Alabama, but to the wider Southeast.

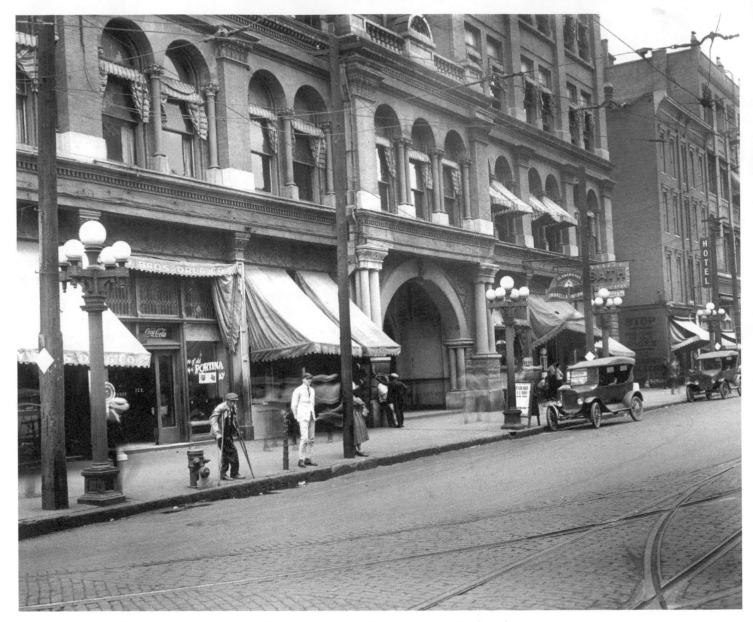

Street-level view of Birmingham's second City Hall on the corner of Fourth Avenue North and Nineteenth Street, around 1920. Much of the first floor was rented out as retail space.

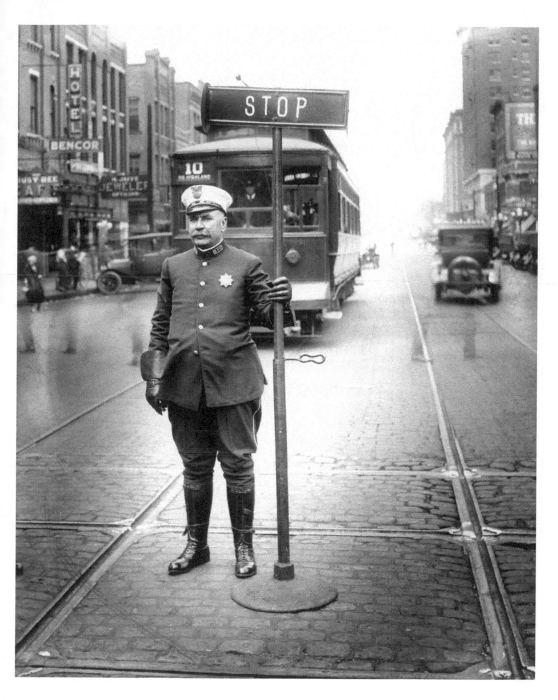

A traffic cop on Twentieth Street North. Before the installation of traffic lights in the early 1920s, police officers directed cars through downtown intersections.

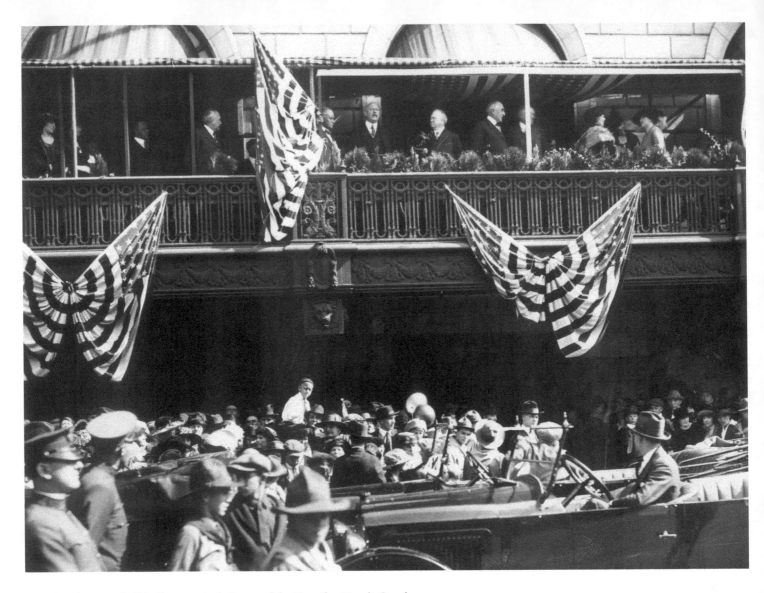

President Warren G. Harding on the balcony of the Tutwiler Hotel, October 1921. Harding visited Birmingham as part of the city's semi-centennial celebration.

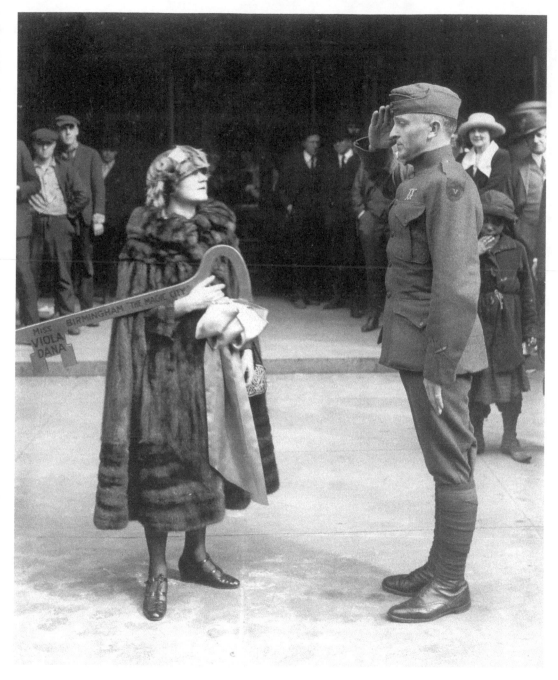

Silent-film star Viola Dana receives a key to the city during her visit to Birmingham in the early 1920s.

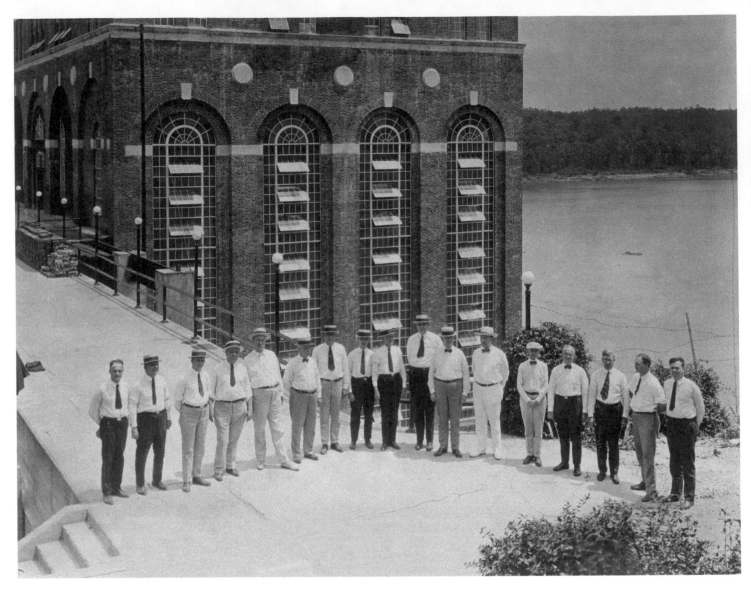

Alabama Power Company board of directors visit Lay Dam, August 18, 1923. Lock 12, later named Lay Dam in honor of Alabama Power founder W. P. Lay, was the first hydroelectric plant constructed by the company. It went into service April 12, 1914. From left to right are J. M. Barry, Thomas Bragg, W. J. Henderson, O. G. Thurlow, W. H. Weatherly, W. H. Hassinger, Frank M. Moody, J. A. Debus, E. C. Melvin, E. A. Yates, R. A. Mitchell, S. Z. Mitchell, Thomas W. Martin, H. G. Abell, Richard M. Hobbie, W. E. Mitchell, and F. P. Cummings.

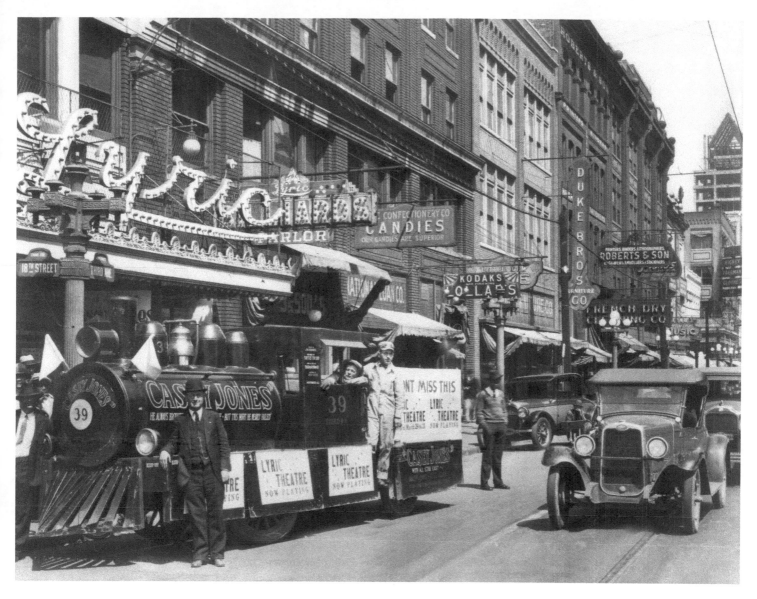

Celebrating Casey Jones outside
the Lyric Theatre, 1928.

The Jefferson County Courthouse on Third Avenue North, with St. Paul's Catholic Church just beyond, in the 1920s.

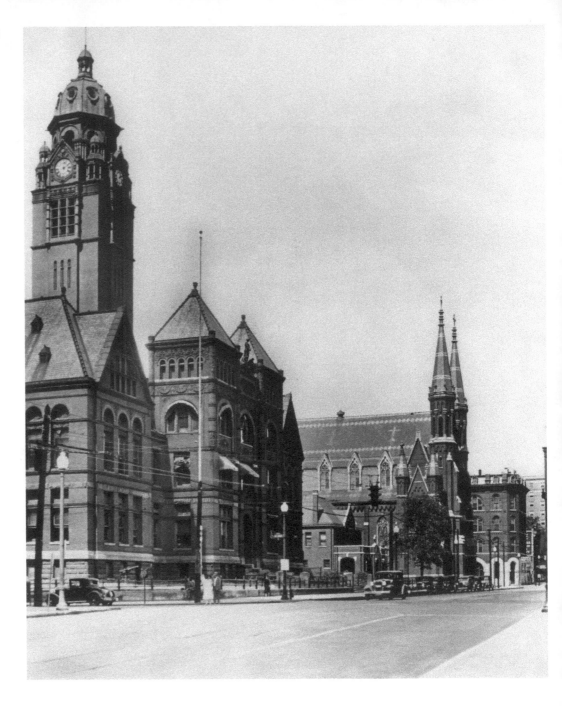

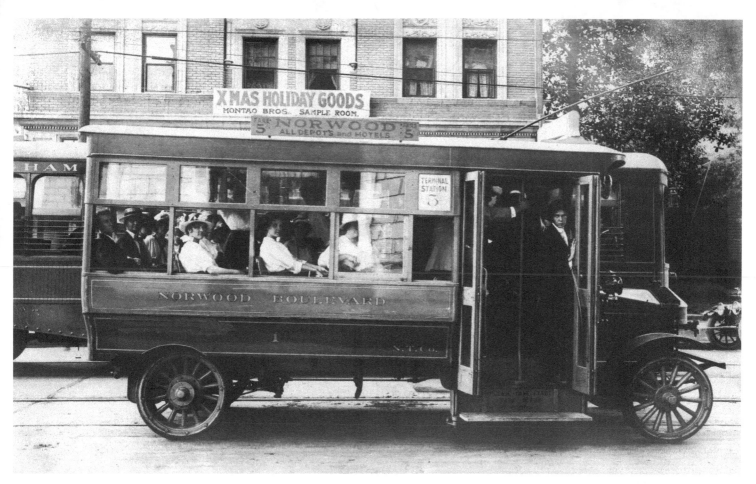

One of Birmingham's "notorious jitneys." In 1923, Birmingham citizens voted overwhelmingly to outlaw these private taxis, which competed with the city's streetcars and whose drivers had been deemed dangerous and irresponsible by the City Commission.

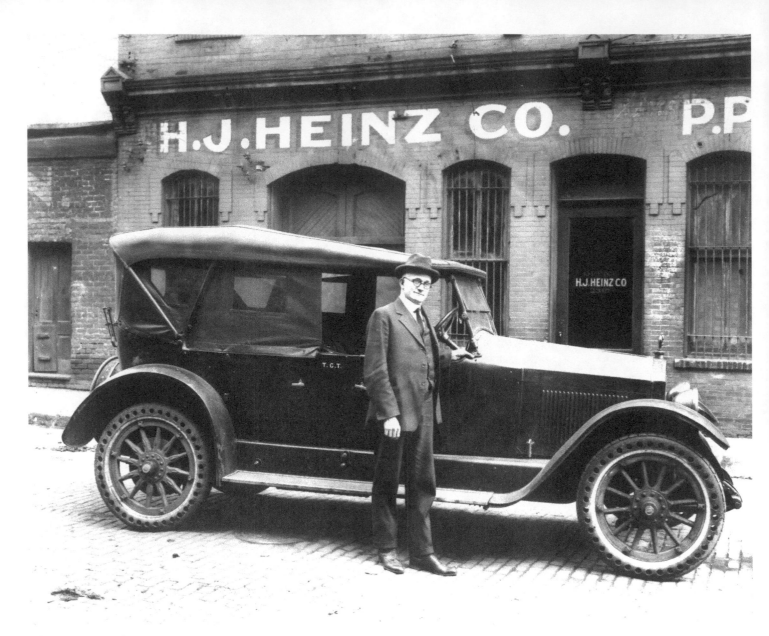

The H. J. Heinz Company on Morris Avenue, 1920s.

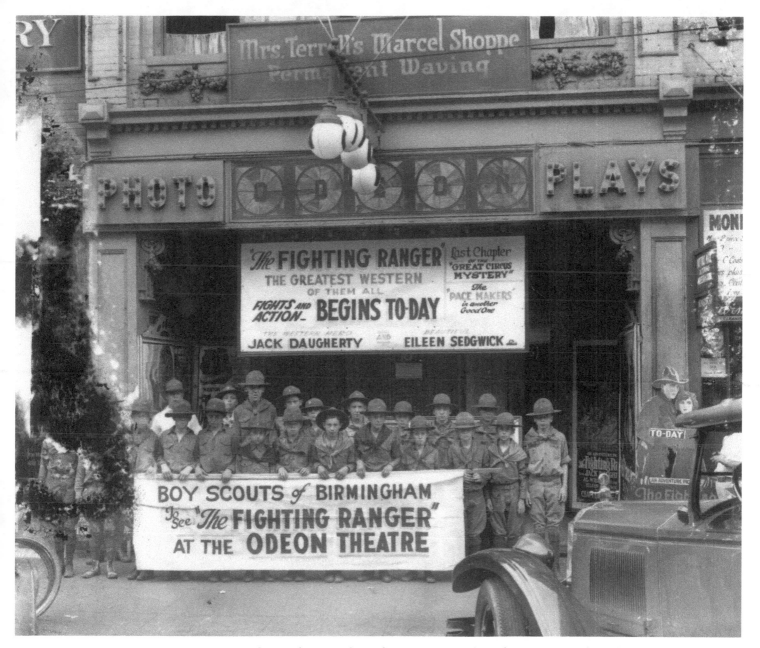

Boy Scouts about to take in the 1925 movie *The Fighting Ranger* at the Odeon Theatre on Second Avenue North.

First Avenue North lined with cars.

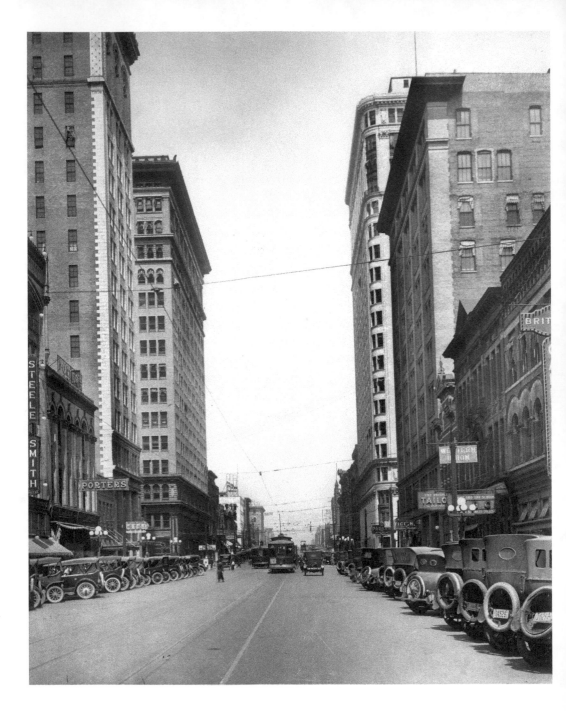

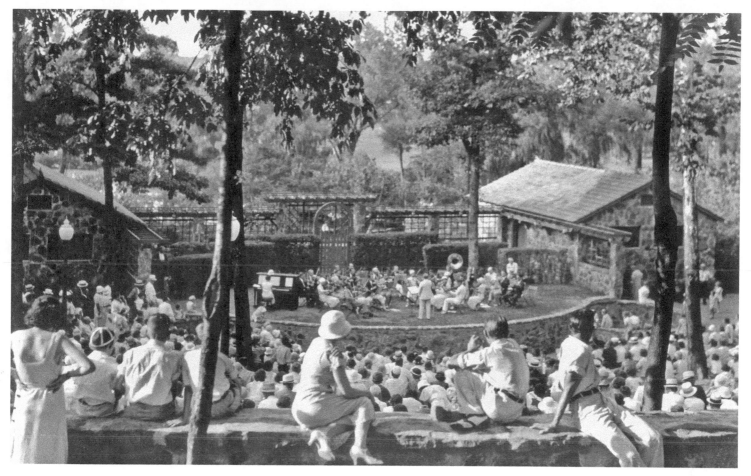

Enjoying a concert in Avondale Park.

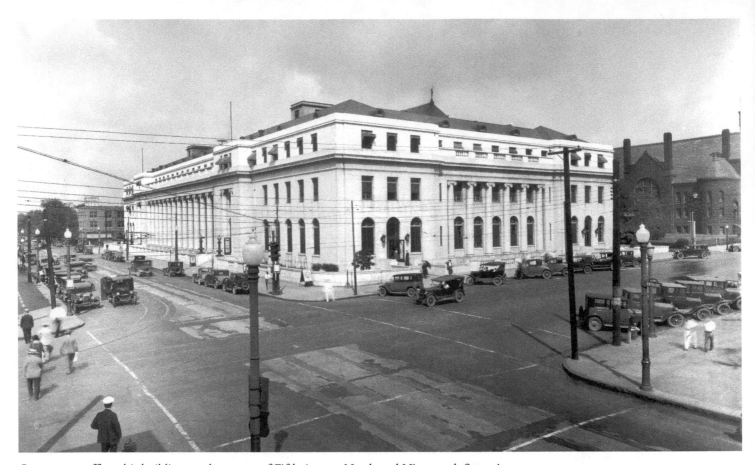

Once a post office, this building on the corner of Fifth Avenue North and Nineteenth Street is now part of the federal courthouse. Today's First United Methodist Church is visible on the right. One Federal Place is now located directly across Fifth.

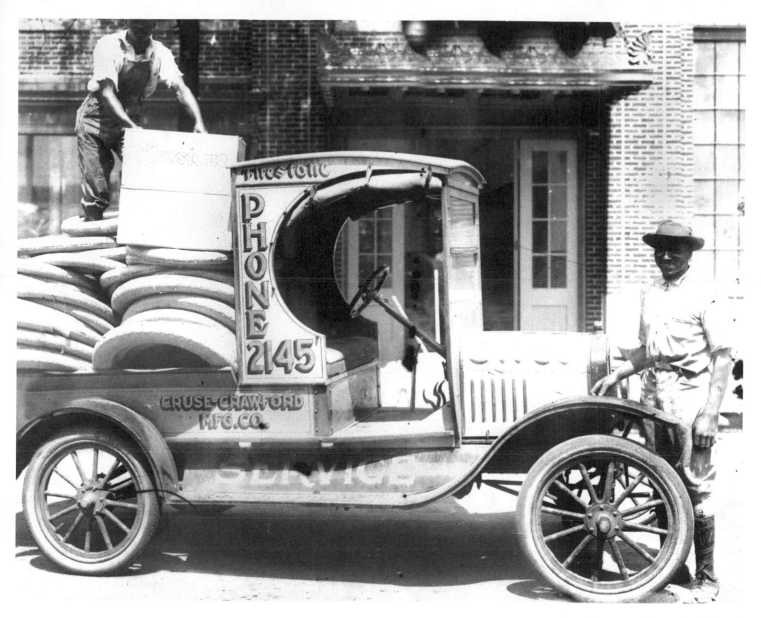

Firestone tires are loaded and
ready for delivery.

Looking down on the intersection of Twentieth Street and Second Avenue North, 1926.

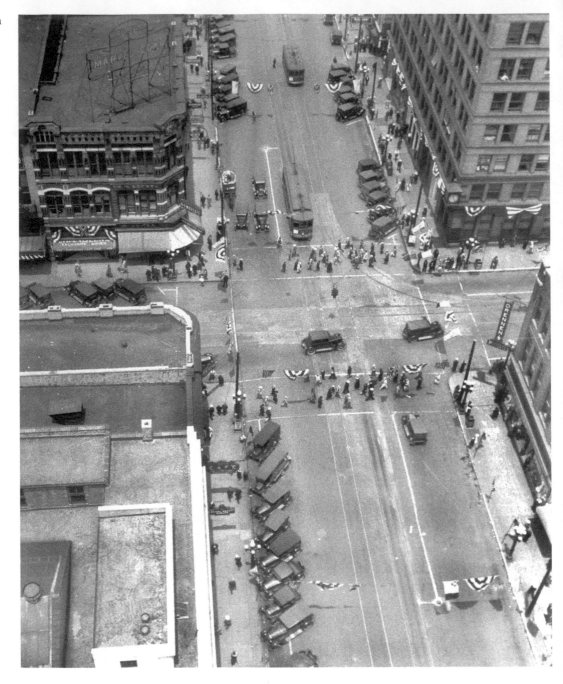

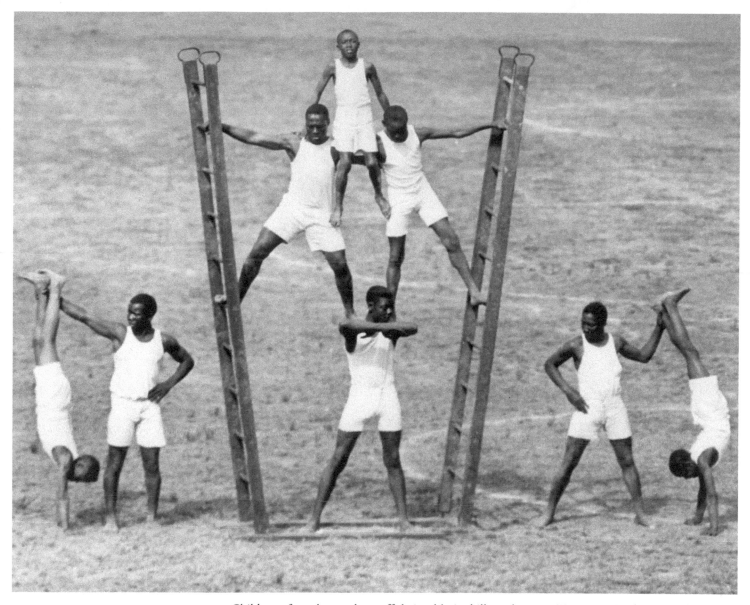

Children of employees show off their athletic skills at the 1928 Tennessee Coal, Iron and Railroad Company's Spring Festival.

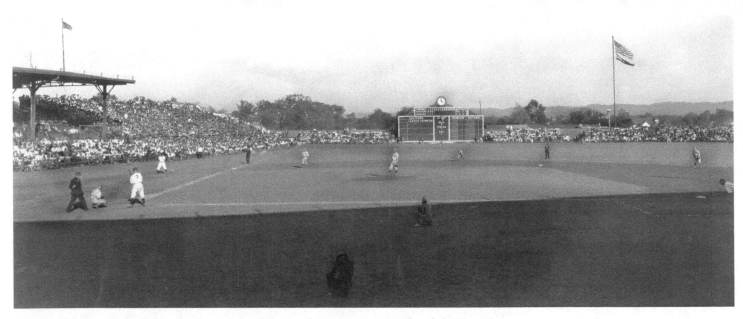

In 1929, the Birmingham Barons, champions of the Southern Association, played the Texas League champions Dallas Steers for the Dixie Series championship. The Barons took the series, 4 games to 2.

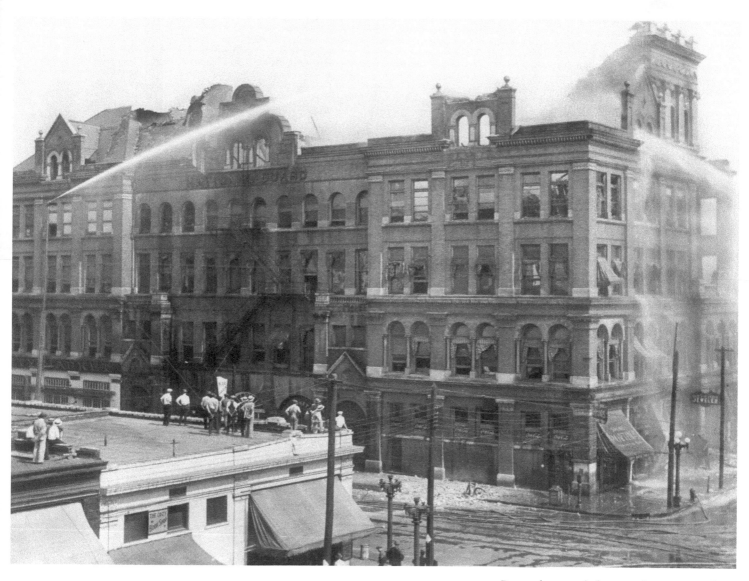

Bystanders watch from rooftops as men from the Birmingham Fire Department extinguish the last embers of the Loveman's fire.

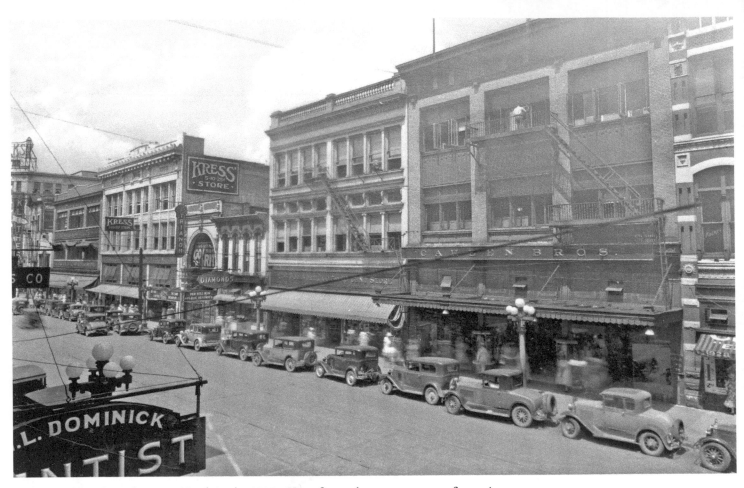

Shopping along Second Avenue North in the 1930s. Kress five-and-ten stores were a fixture in many American cities in the era.

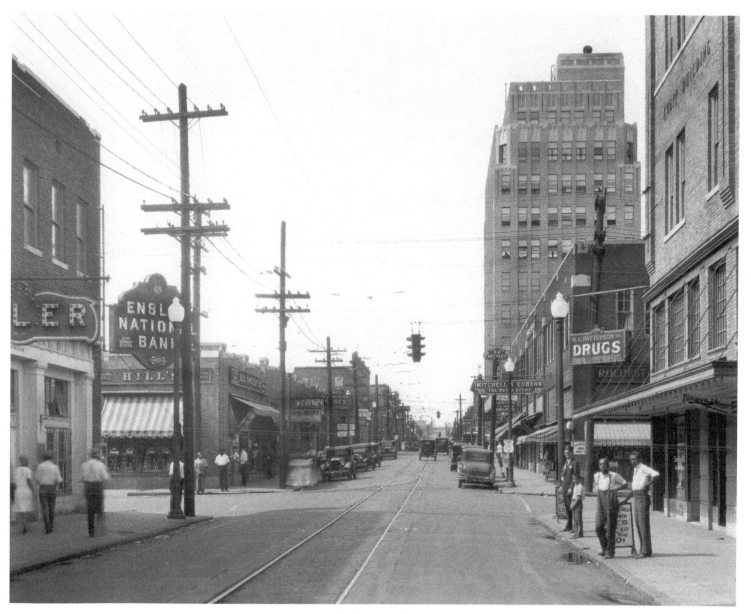

The business district of Ensley, Avenue F and Nineteenth Street, in the 1930s.

Twentieth Street at Second
Avenue North in the 1930s. The
tall building in the center is the
Watts Building.

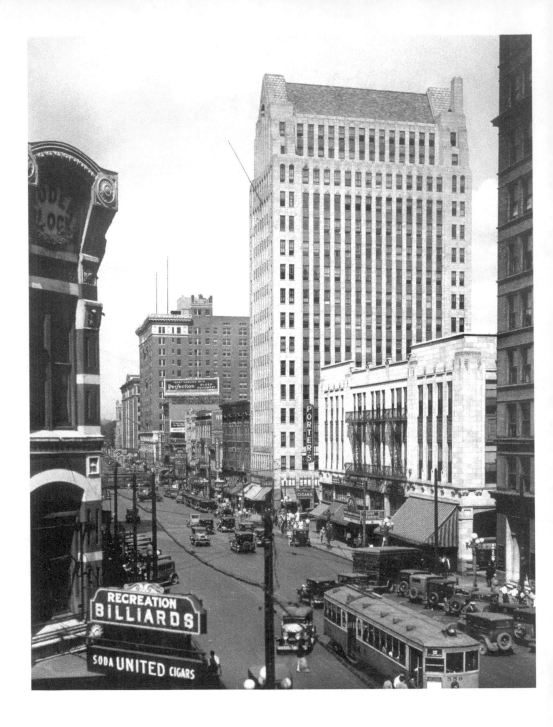

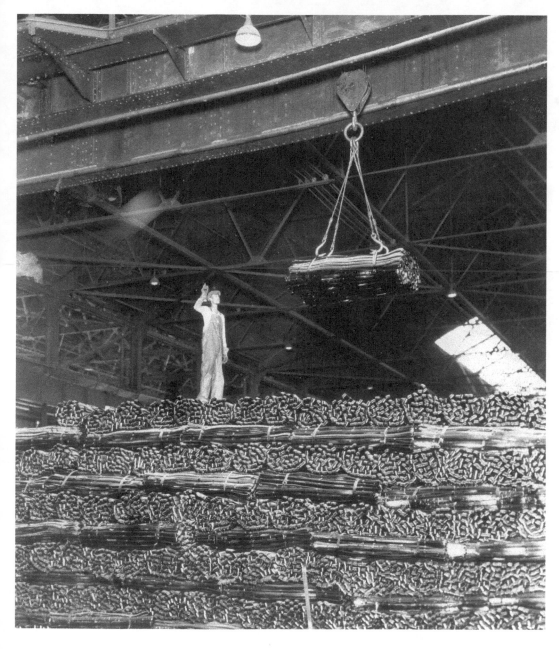

Cotton ties being warehoused. Ties for cotton bales were manufactured year-round and stored until cotton was harvested in the late summer and fall.

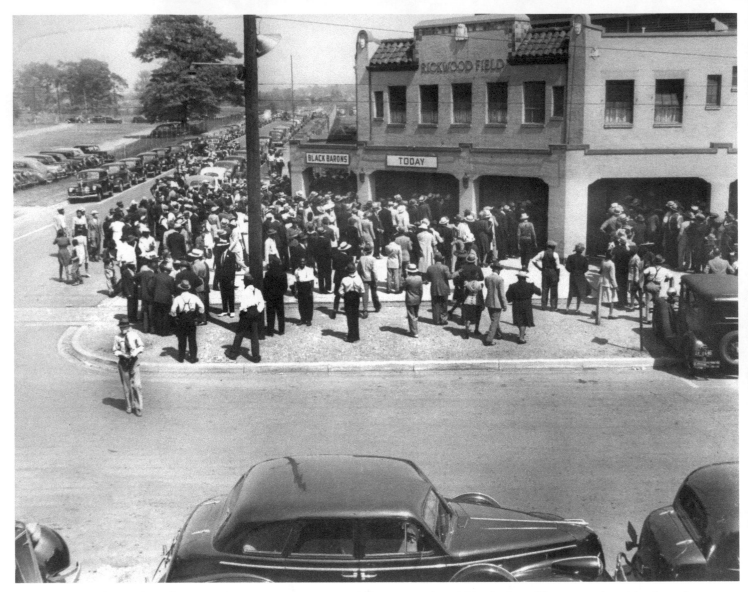

Like so much of life in the early twentieth century, sports were racially segregated, and Birmingham, like many other cities, hosted two professional baseball teams. The white Birmingham Barons and the Birmingham Black Barons shared Rickwood Field. When the white Barons played, white spectators sat in the grandstand and black spectators in the bleachers. When the Black Barons played, the seating was reversed.

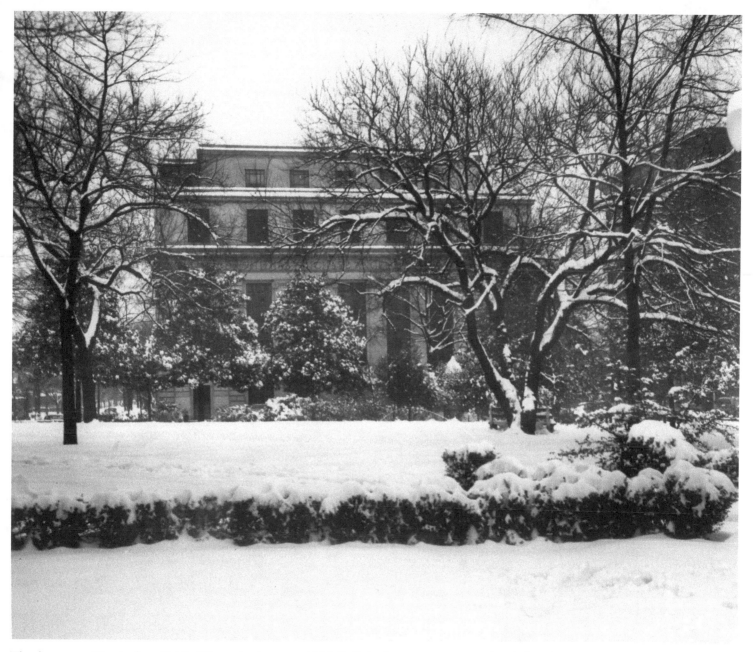

The downtown Birmingham Public Library in the snow, 1936. Built in the 1920s as Birmingham's first free-standing central library, this building now houses one of the finest genealogical and local history collections in the United States and Alabama's first municipal archives.

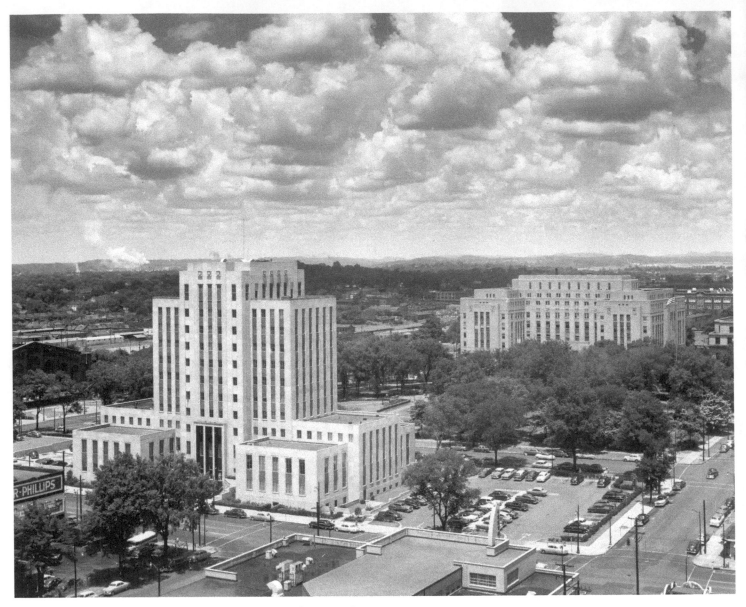

Birmingham City Hall and the Jefferson County Courthouse in the 1950s.

DIFFICULT DAYS AND CHANGING TIMES

(1940–1960s)

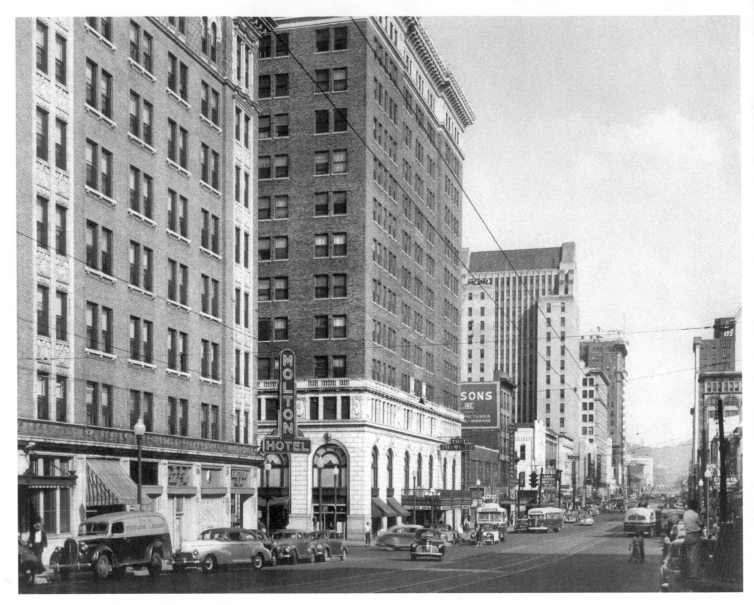

Looking south on Twentieth Street, 1940s.

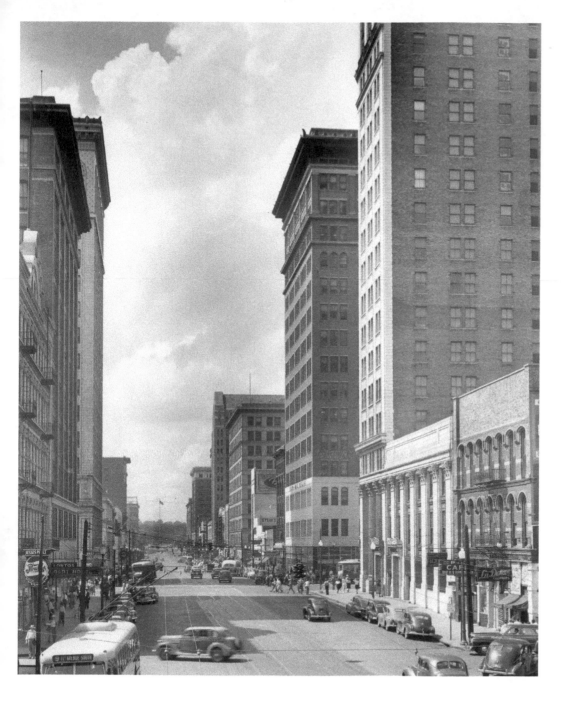

Looking north on Twentieth Street from Morris Avenue, 1940s.

One of Birmingham's oldest churches, First Presbyterian, is shown here as it appeared in the 1940s.

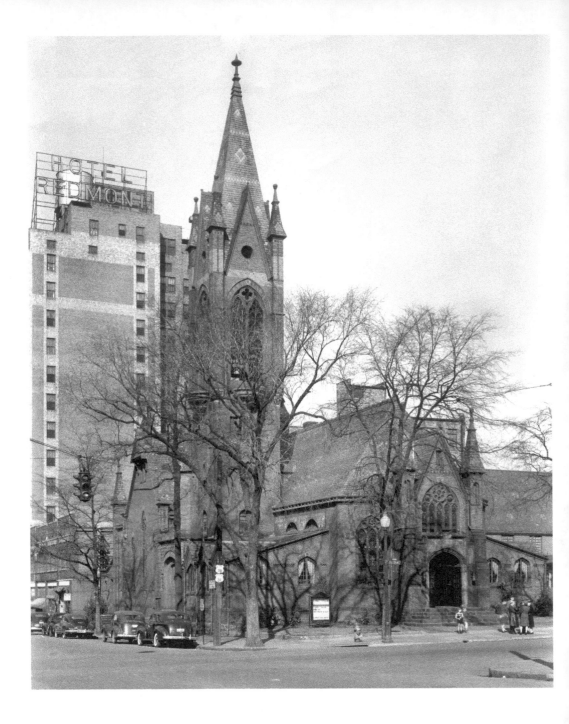

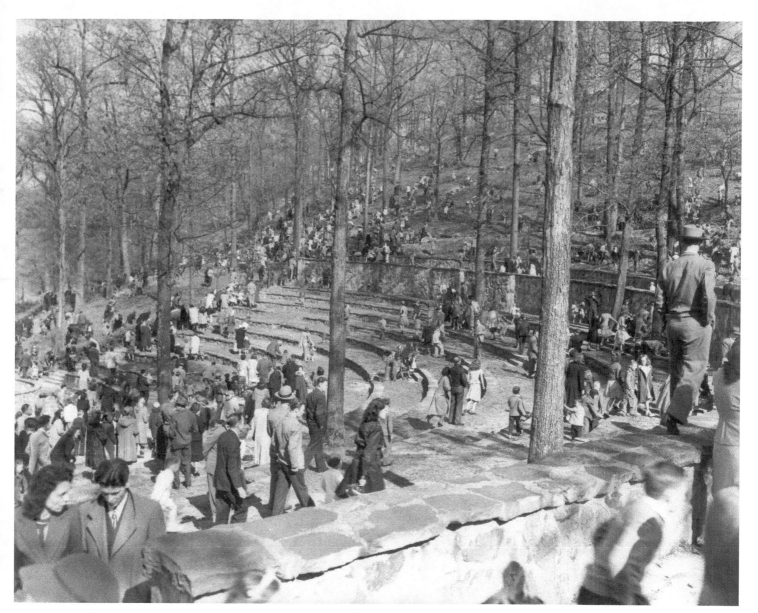

Easter egg hunt at Avondale Park, late 1940s.

During the era of racial segregation, many white-owned businesses in Birmingham did not serve African-American customers. To provide for the black community, black-owned businesses like Tom's Real Shine, the Famous Theater, and others operated on and around Fourth Avenue North. This area, now known as the Black Business District, is listed on the National Register of Historic Places.

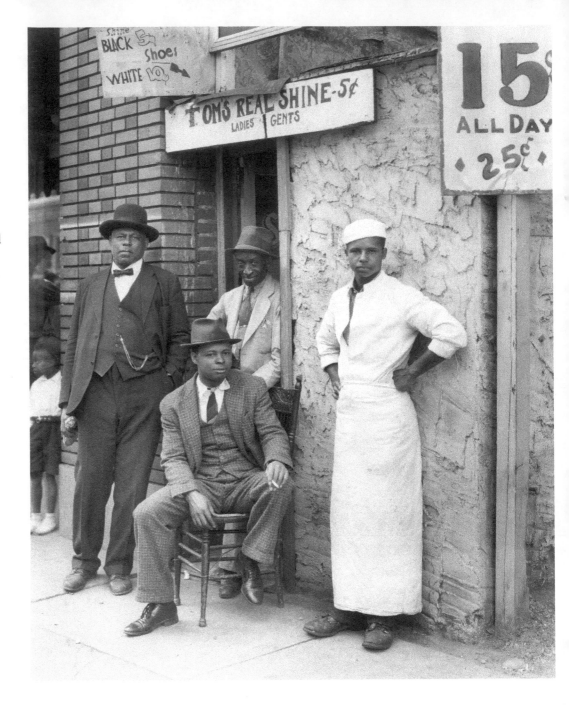

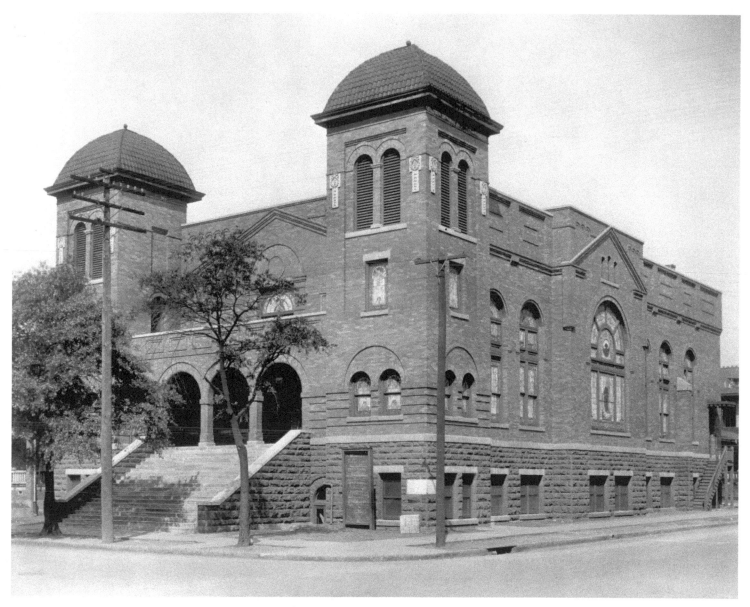

Sixteenth Street Baptist Church, one of Birmingham's oldest African-American congregations.

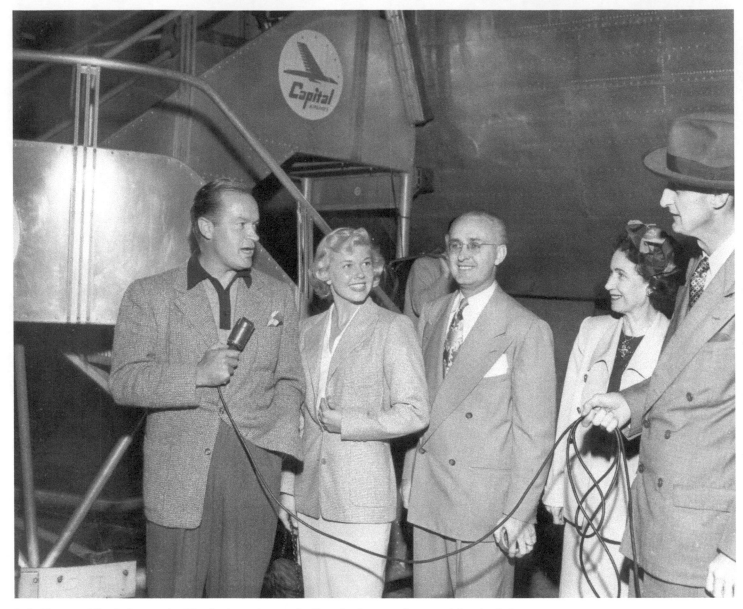

Bob Hope and Doris Day at the Birmingham airport, April 1949. In town for one night, the Bob Hope Show treated a packed audience at the Municipal Auditorium to music and comedy.

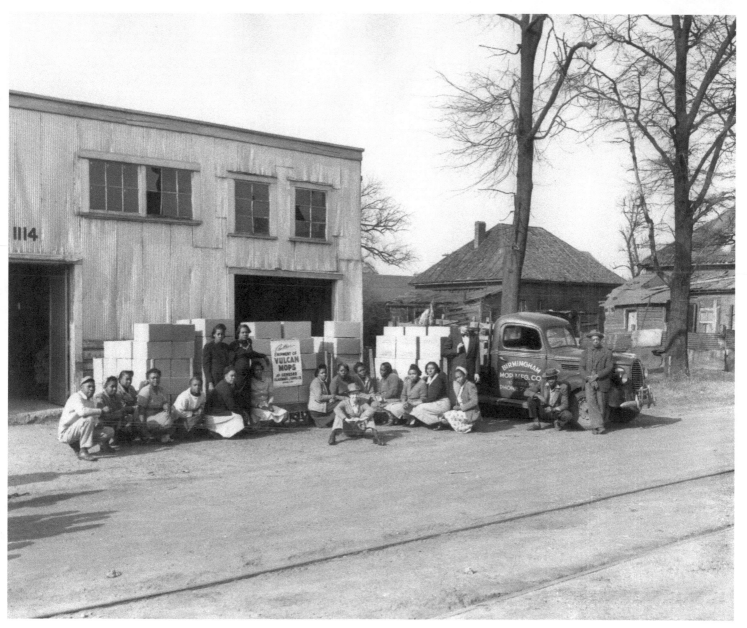

Employees of the Birmingham Mop Manufacturing Company on Fifth Avenue South, 1949.

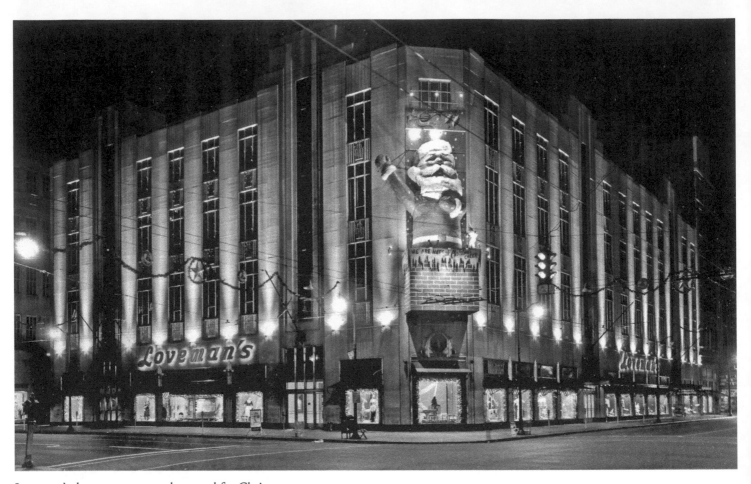

Loveman's department store, decorated for Christmas.

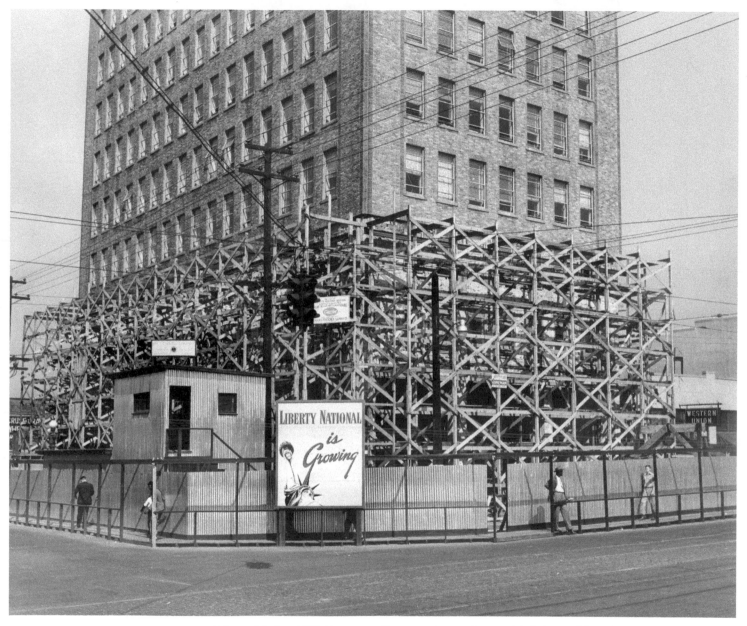

Liberty National Life Insurance Company is growing, 1946. Brice Building Company renovated the original ten-story building built around 1923.

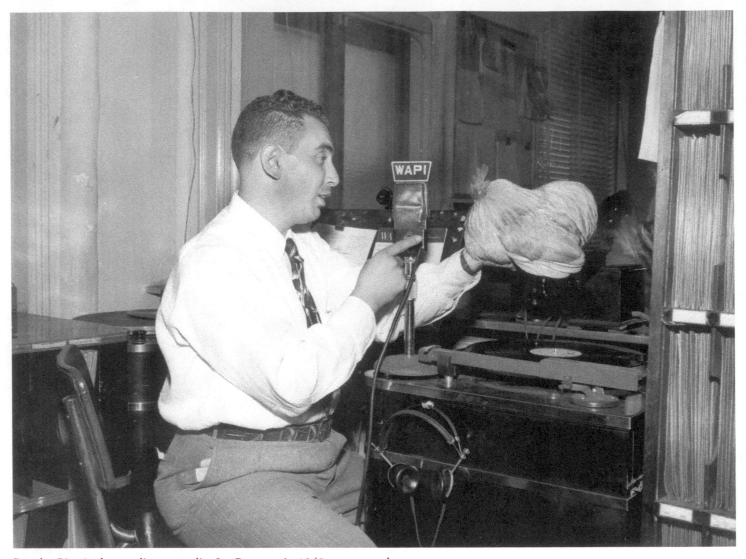

Popular Birmingham radio personality Joe Rumore, in 1948, appears to be interviewing a fowl either short on clucks or slow to crow.

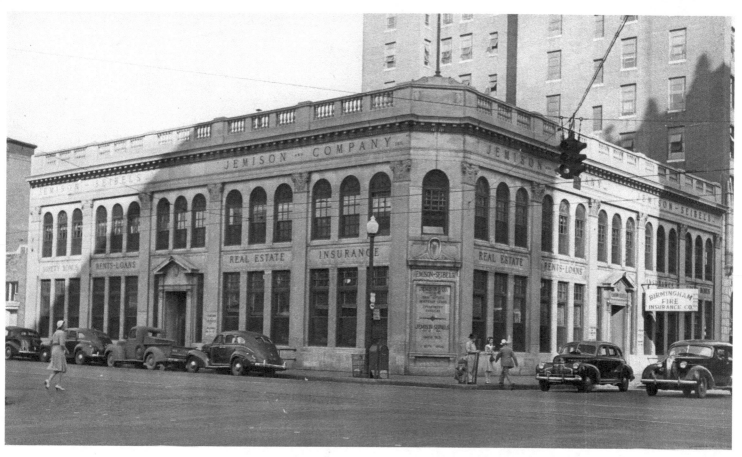

Known during his lifetime as "Mr. Birmingham," Robert Jemison, Jr., developed many of the area's buildings and communities, from Fairfield to Mountain Book. Here the Jemison Company headquarters is shown on Twenty-first Street North.

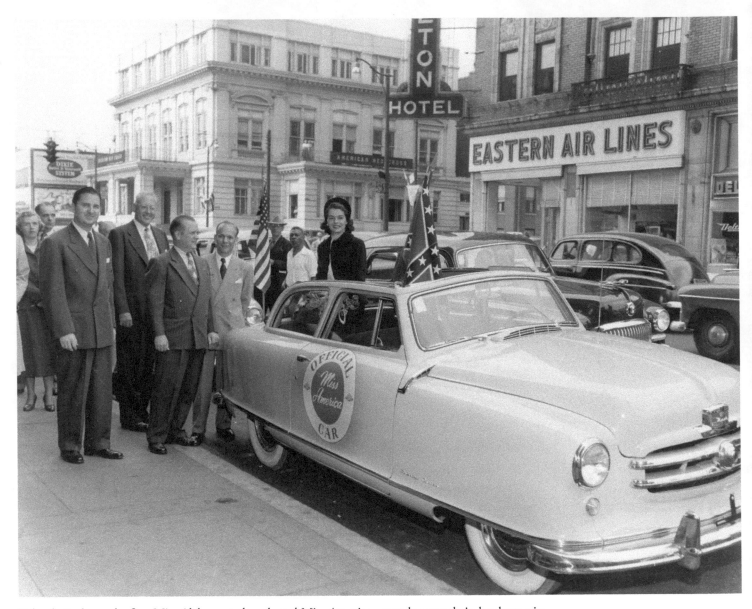

Yolanda Betbeze, the first Miss Alabama to be selected Miss America, attends a parade in her honor in downtown Birmingham in 1951. In later years, Betbeze took part in civil rights demonstrations and sit-ins.

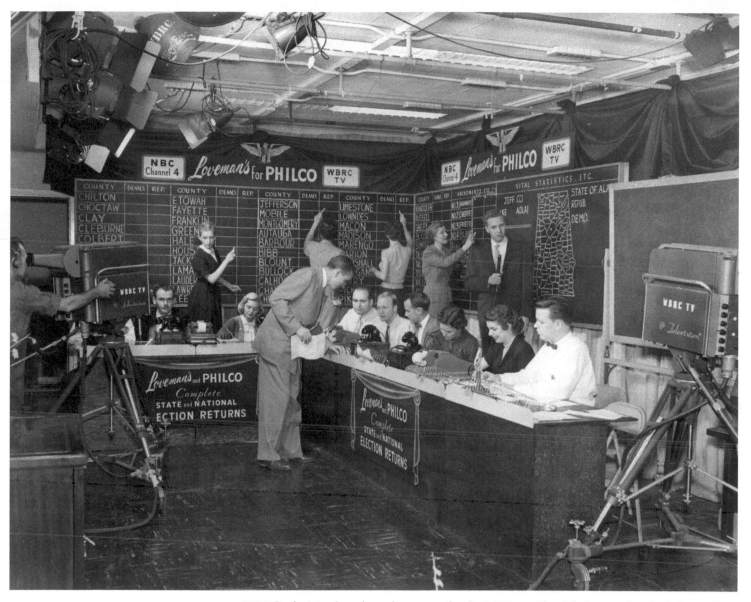

WBRC television broadcast the returns for the 1952 presidential election, in which Republican Dwight Eisenhower and Democrat Adlai Stevenson were running for the office.

For decacades, people in rural areas looked forward to the visits from the Birmingham Public Library's bookmobile. Shown here in the 1950s, this bookmobile was called a "traveling branch."

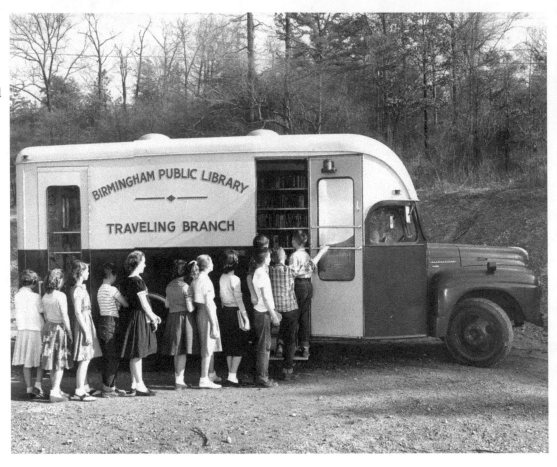

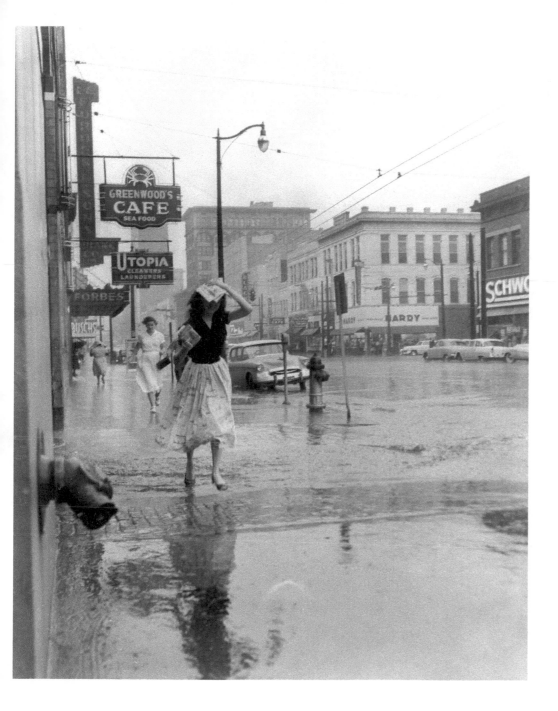

A rainy day on Twentieth Street North, July 1955.

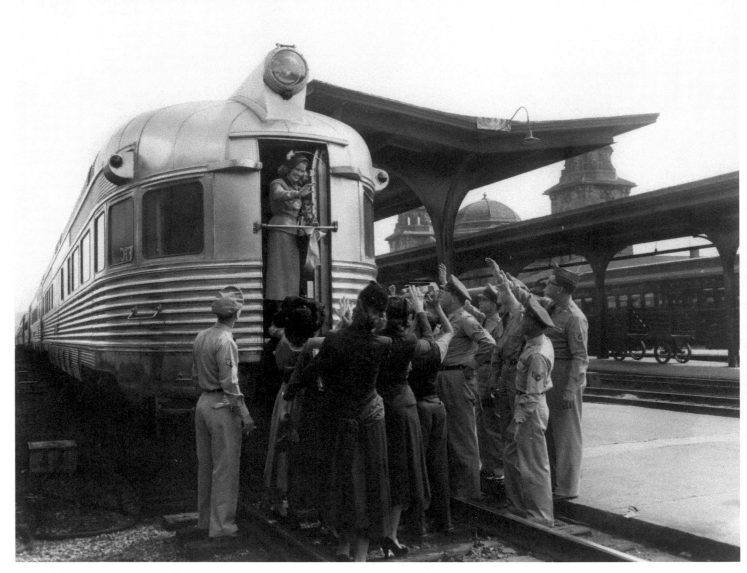

Miss Alabama Gwen Harmon leaves Terminal Station in 1952.

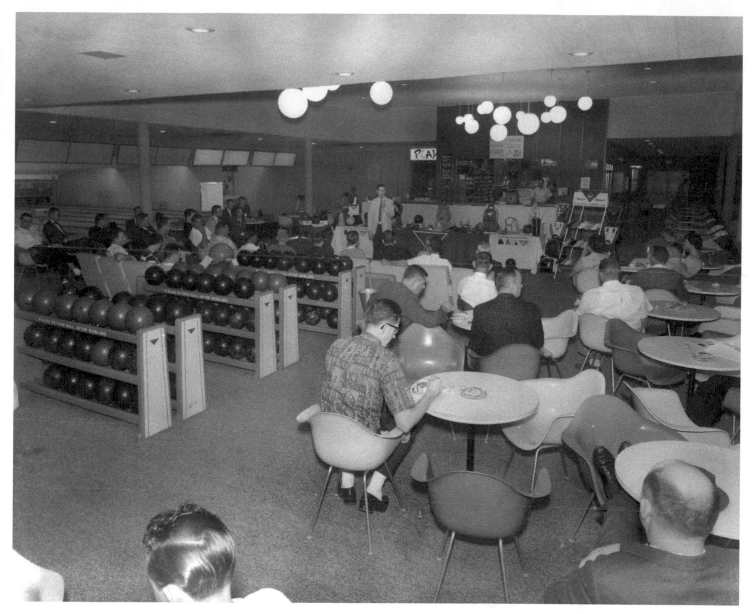

Ready to bowl at Eastwood.

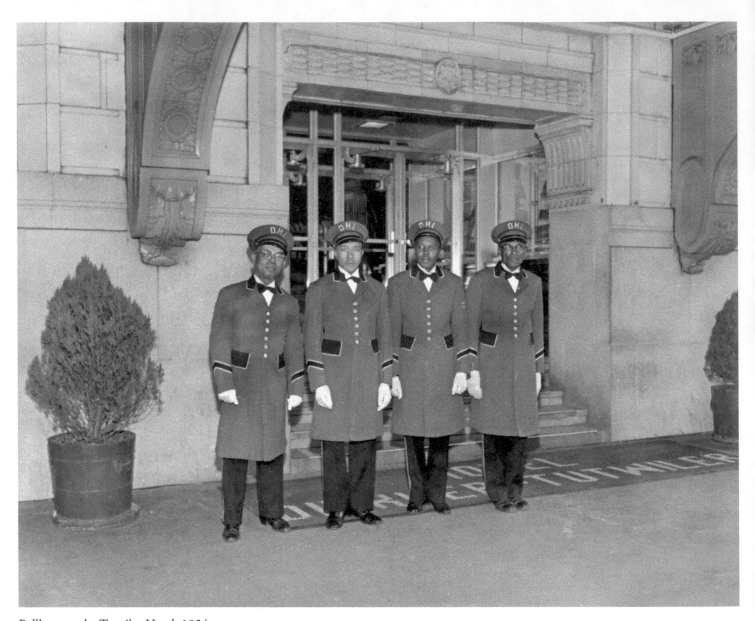

Bellhops at the Tutwiler Hotel, 1954.

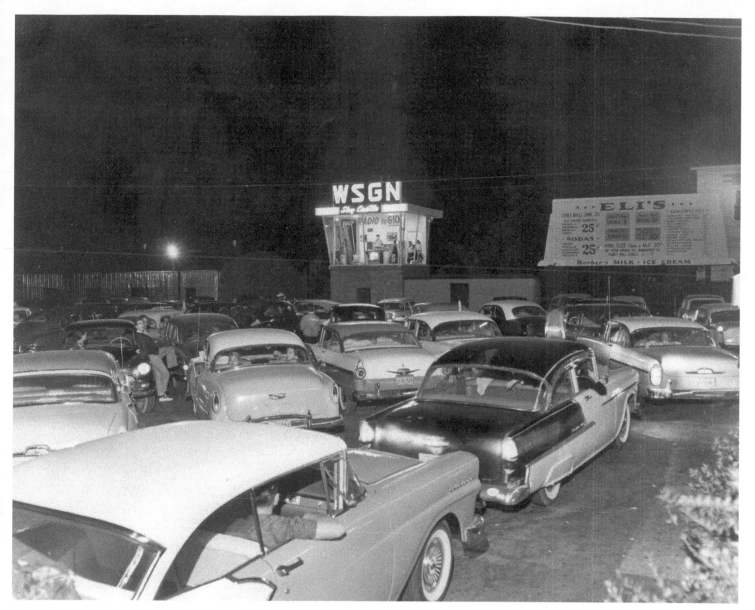

Teenagers gather to hear WSGN radio broadcasting from the Sky Castle, 1956.

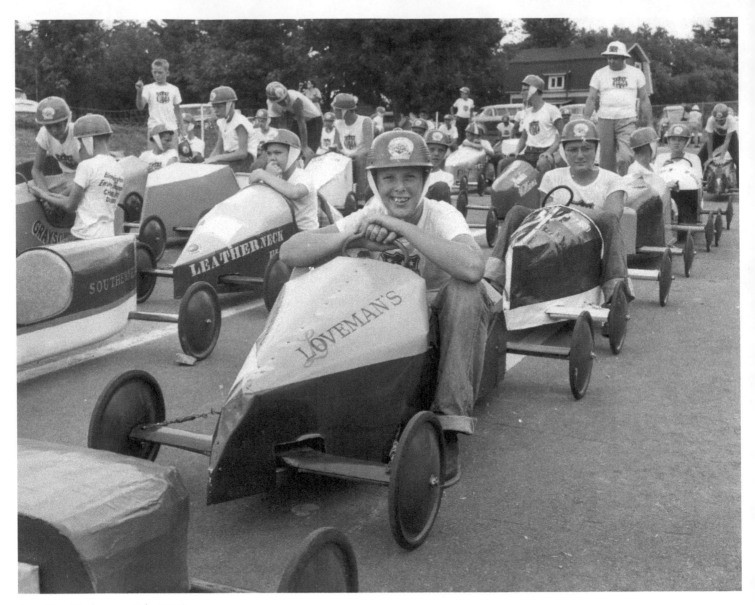

Soap Box Derby race, July 1956.

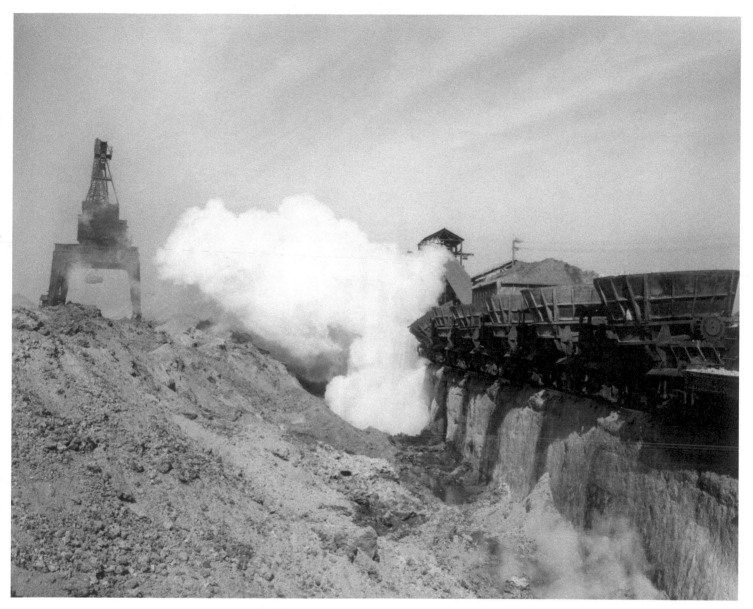

Expanded slag pit at Ensley. Vulcan Materials Company's predecessor, Birmingham Slag, took slag, a waste product from Birmingham's steel industry, and processed it for use as railroad ballast and an aggregate in road building.

A concrete truck (with the Birmingham Slag Division logo) is loaded with ready-mixed concrete at a Vulcan Materials plant in Fairfield. The Birmingham Slag Division was in existence from 1956 to 1964, when it became a part of Vulcan's Southeast Division.

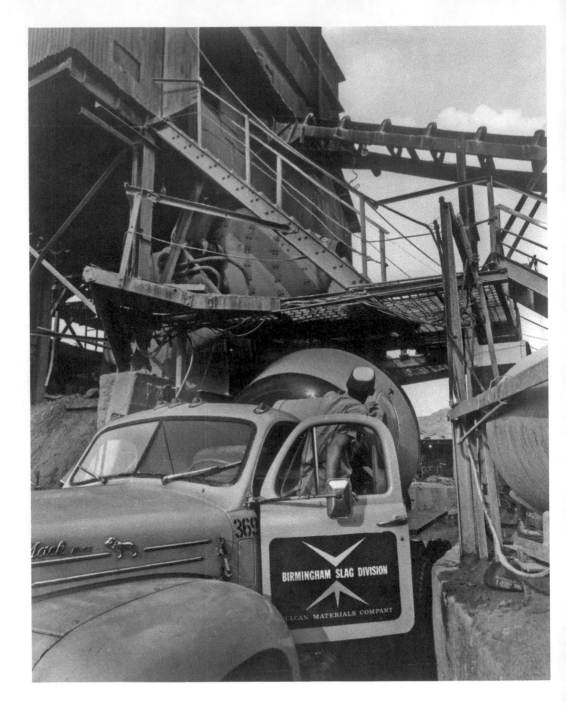

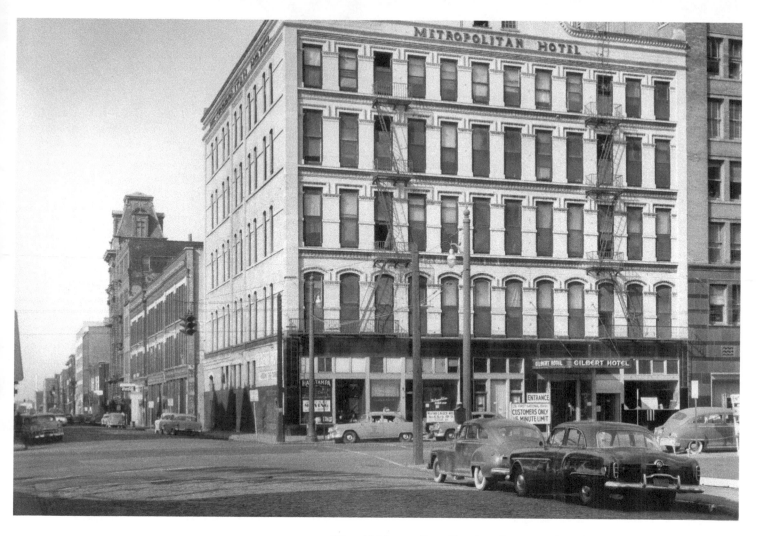

The old Metropolitan Hotel, well past its glory days and renamed the Gilbert, on the corner of Twentieth Street and Morris Avenue, 1950s.

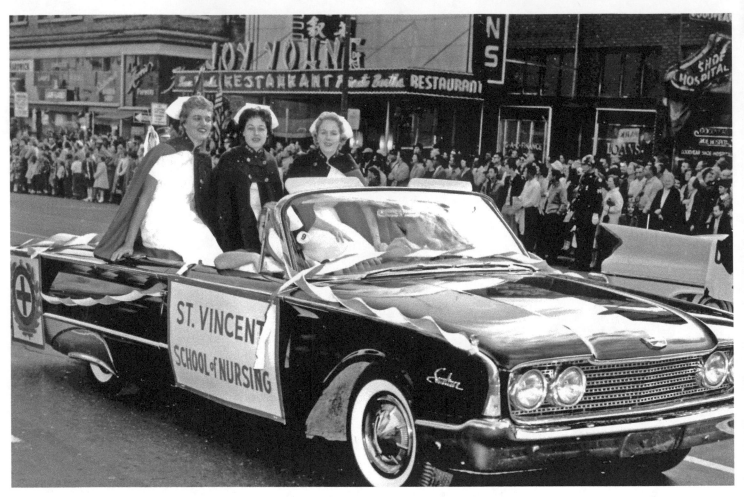

Students from St. Vincent's School of Nursing participate in the 1959 Veterans Day parade.

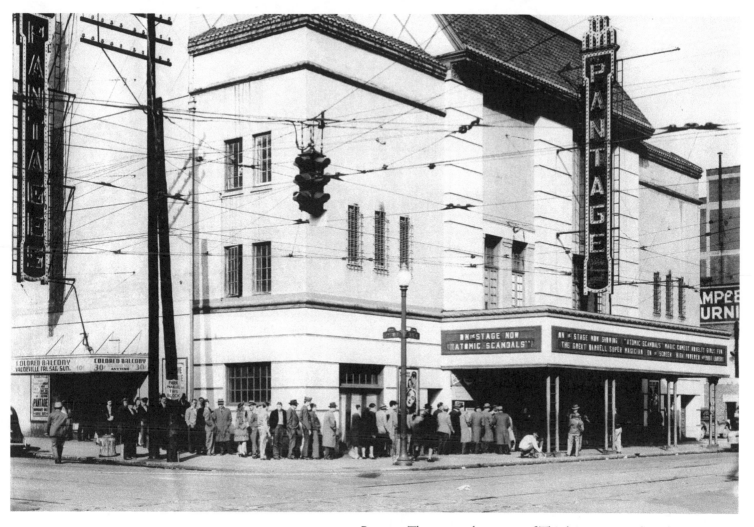

Pantages Theater on the corner of Third Avenue North and Seventeenth Street. Prior to 1963, most public facilities in Birmingham were racially segregated, and here the entrance to the "Colored Balcony" is visible on the side of the building.

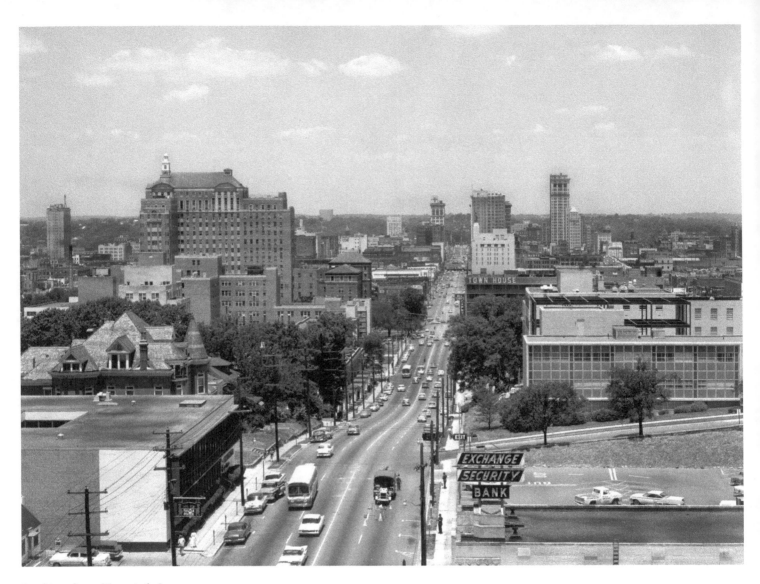

Looking down Twentieth Street
from atop the Medical Arts
Building (now the Pickwick
Hotel), 1961.

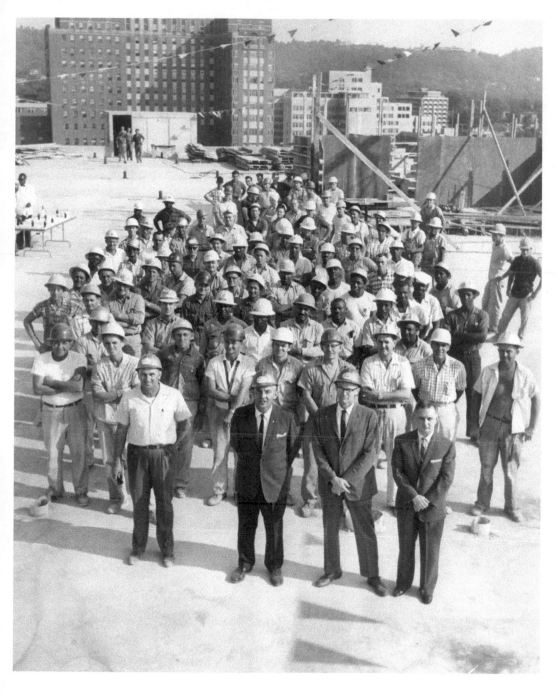

The Parliament House, 1962. Brice Building Company's construction team celebrates the topping out of Birmingham's first new multi-story motor hotel.

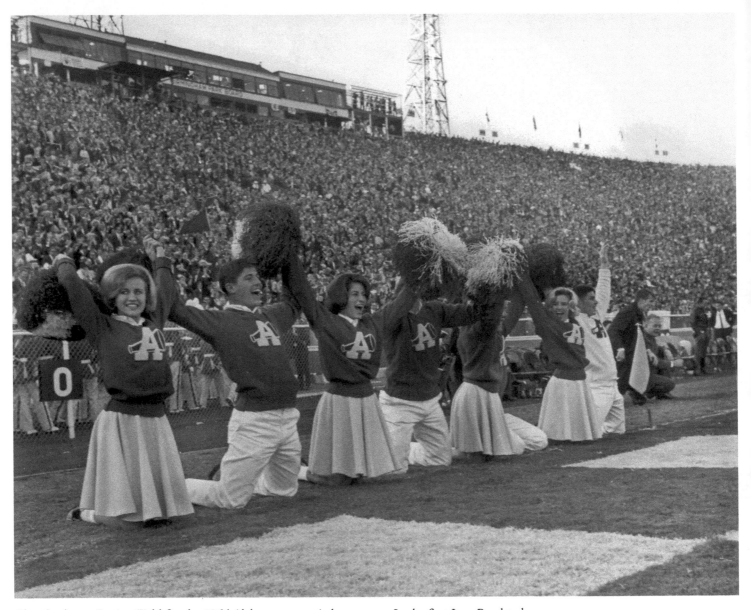

Cheerleaders at Legion Field for the 1964 Alabama versus Auburn game. In the first Iron Bowl to be televised to a national audience, quarterback Joe Namath led the Tide to a 21-14 victory.

NOTES ON THE PHOTOGRAPHS

These notes attempt to include all aspects known of the photographs. Each of the photographs is identified by the page number, photograph's title or description, photographer and collection, archive, and call or box number when applicable. Although every attempt was made to include all data, in some cases complete data may have been unavailable.

II **TERMINAL STATION WITH THE MAGIC CITY SIGN**
Photo by O.V. Hunt
Birmingham Public Library Archives
OVH 85

VI **PLACING FIRST COLUMN FOR TUTWILER HOTEL**
Photo by O.V. Hunt
Birmingham Public Library Archives
15.54

X **FIRST AVENUE NORTH**
Photo by unknown photographer
Birmingham Public Library Archives
38.06

2 **EARLIEST KNOWN PHOTOGRAPH OF BIRMINGHAM**
Photo by A. C. Oxford
Birmingham Public Library Archives
6.57

3 **JEFFERSON COUNTY COURTHOUSE**
Photo by unknown photographer
Birmingham Public Library Archives
34.05

4 **GEORGIA-PACIFIC RAILROAD ENGINE**
Photo by A. C. Oxford
Birmingham Public Library Archives
37.17

5 **PASSENGER TRAIN**
Photo by unknown photographer
Birmingham Public Library Archives
17.68

6 **RODEN'S BOOK STORE**
Photo by Bob Baker
Birmingham Public Library Archives
4.91

7 **HOME OF ROBERT JEMISON, SR.**
Photo by unknown photographer
Birmingham Public Library Archives
15.28

8 **JEFFERSON COUNTY COURTHOUSE**
Photo by J. Horgan, Jr.
Birmingham Public Library Archives
14.47

9 **NINETEENTH STREET NORTH AT SECOND AVENUE**
Photo by J. Horgan, Jr.
Birmingham Public Library Archives
20.28

10 **GATE CITY STREETCAR**
Photo by O.V. Hunt
Birmingham Public Library Archives
8.06

11 **GOING FOR A RIDE**
Photo by unknown photographer
Birmingham Public Library Archives
1.14

12 **SHRINERS ON PARADE**
Photo by O.V. Hunt
Birmingham Public Library Archives
OVH 450

13 **BIRMINGHAM STREETCARS**
Photo by J. Horgan, Jr.
From a copy by O. V. Hunt
Birmingham Public Library Archives
OVH 434

14 **PIONEER MINING AND MANUFACTURING COMPANY**
Photo by unknown photographer
Erskine Ramsay Papers
Birmingham Public Library Archives
1.3.61

Printed in the USA
CPSIA information can be obtained
at www.ICGtesting.com
JSHW072023140824
68134JS00042B/3759

9 781683 368113